The T.W. Lawson

The T.W. Lawson

The Fate of the World's
Only Seven-Masted Schooner

Thomas Hall

THE
History
PRESS

Published by The History Press
Charleston, SC 29403
www.historypress.net

Cover image: The *T.W. Lawson* at sail.

First published 2005
The History Press edition 2006

ISBN 978-1-5402-0444-8

Library of Congress Cataloging-in-Publication Data

Hall, Thomas (Thomas Stephen), 1962-
The T.W. Lawson : the fate of the world's only seven-masted schooner /
Thomas Hall.
p. cm.
ISBN-13: 978-1-59629-208-6 (alk. paper)
ISBN-10: 1-59629-208-3 (alk. paper)
1. Shipwrecks--England--Scilly, Isles of--History--20th century. 2. Oil
spills--England--Scilly, Isles of--History--20th century. 3. T.W. Lawson
(Ship) 4. Lawson, Thomas William, 1857-1925. I. Title.
G530.T218H35 2006
910.9163'36--dc22
2006027902

For my daughters Nicole and Chloe

Ah! what pleasant visions haunt me
as I gaze upon the sea!

All the old romantic legends,
All my dreams, come back to me

CONTENTS

ACKNOWLEDGEMENTS

I've lived and breathed this story for a couple of years now, and I'm happy to have gotten it down on paper to share with you. I have even had the opportunity to present this research at several maritime museums on the East Coast and fortunately convinced Alec Collyer from the BBC to come over to the States and help with some of them.

I'm particularly grateful to Mark Groves, Alec Collyer, Maggie Tucker and Osbert Hicks, who've opened up their homes, shared stories and graciously helped me piece together this story.

I would also like to thank all the good people on the Isles of Scilly especially John Hicks and Joe Hicks for sharing their family history; Mike Gurr and the Maritime Museum on St. Mary's; all the shareholders of the gig *Slippen*; Clive Mumford, editor of the *Scillonian*; Gilbert Pender, for his donation of the porthole; John Thompson, for his model of the *Slippen*; master divers George Gradon and Mervyn Waldron; and Julia Peet and Stephen Hall from the BBC Southwest.

On this side of the Atlantic, I would like to thank Dick Moll and Karin Soderberg at the Mystic Seaport; Kurt Hasselbalch at the MIT Museum; Dave Ball, John Galluzzo and Pam Martell of the Scituate Historical Society; Mike Jenness and Team Saquish; Lynn Petropulos, for her artistic talent and friendship; the Calderone and Quinn families for sharing their Dow family history; the Crowninshield families for sharing their remembrance of "Bodie" Crowninshield; Martin Fryer for his skilled design; Marie Deer for her editorial review; and finally my family for encouraging me to complete this book. I could not have finished this without the support of all of you—thanks!

Photos of the *T.W. Lawson* can be found in the MIT Museum, Mariner's Museum, Peabody Essex Museum, Mystic Seaport, Society for the Preservation of New England

Antiquities, and Quincy and Scituate Massachusetts Historical Societies. Other photos graciously came from the private collections of the Collyer, Gibson, Crowninshield, Hall, Hicks and Calderone-Quinn families.

INTRODUCTION

A Wreck

On November 19, 1907, at Marcus Hook refinery in Pennsylvania, the world's only seven-masted schooner *T.W. Lawson* was loaded with its cargo of two and a quarter million gallons of light oil and readied for the transatlantic trip to England. The *Lawson* proceeded to the Atlantic Ocean and set off on a great circle route toward London, over three thousand miles away. The weather along the eastern seaboard was fair as the ship began its crossing.

At normal cruising speeds of eight or nine knots, in fair weather, the *T.W. Lawson*'s trip should have taken about fifteen days, maybe sixteen, depending on the currents. But the big, clumsy schooner, on its first transatlantic crossing and with a mostly very young and inexperienced crew, ran into three gales along the way. All but six of the sails were ripped. All three lifeboats were splintered. And when the ship finally came in sight of land, after twenty-five days at sea, it turned out the *Lawson* was just northeast of Bishop's Rock Lighthouse, in the Isles of Scilly, off the far southwestern tip of England. In order to sail to London, the ship should have kept well south and west of Bishop's Rock and then turned up the channel between England and France toward London.

Not only was the ship on the wrong side of Bishop's Rock, it was also right in the middle of the Isles of Scilly's dangerous Western Rocks, where hundreds of ships have been wrecked over the centuries. But the ship's captain, George Dow, thought at least he could secure the anchors here and let the crew rest. With a tugboat, a local pilot, a rested crew and weather sure to be calmer than the gale that was raging that afternoon, he would ease the ship out of its tricky position in the morning.

That never happened. By daybreak, Saturday, December 14, the ship was broken in two and turned upside down. Fifteen of the eighteen-man crew, along with Billy Cook Hicks, the local pilot who'd come aboard, were dead, from drowning or mangling or both (and another would soon die of his wounds). And the waters around the Isles of Scilly were covered in two and a quarter million gallons of oil, one of the world's first major ecological disasters.

What went wrong? I've been to the Isles of Scilly many times now, talking to the descendants of the lifeboat rescue crew, diving on the wreck of the *T.W. Lawson*, and researching the records there. I've talked to the descendants of Captain Dow, designer B.B. Crowninshield and financier Thomas Lawson, and researched the records at the shipyard where the ship was built and at maritime museums up and down the coast.

This is the story I've unearthed, of the wreck of the world's first and only seven-masted schooner on its first trip across the Atlantic. It's a story that takes place on two coasts: a story that begins in seaside Scituate, Massachusetts, with the vision of Boston financier Thomas W. Lawson and ends on the rocks of the Isles of Scilly, where an American captain and his crew faced an impossible decision.

FAMILIES REMEMBER

One of my father's most-read books was Friday the Thirteenth, which was translated into many languages, and so Father and Friday the Thirteenth were joined in the public's mind.

On Friday, December 13, 1907, I had just come home for Christmas vacation from St. Paul's school and, as was our custom, Father and I talked late into the night. I remember so well his closing words, "Well, this Friday the thirteenth went off without anything going wrong."

A few hours later, clad in our bathrobes, Father stood beside me while I took the call which came over the telephone in the early hours of Saturday morning. I cannot remember the exact wording, but the purport has always been clear in my memory. The T.W. Lawson *had broken her moorings and was presumably a wreck off Annet Head on the shores of Scilly Isles.*

—Douglas Lawson, son of Thomas W. Lawson

In 1998, two members of our family, Betsy and David, traveled from their London home by train to Penzance and then by helicopter to the Isle of Tresco to investigate the wreck of the T.W. Lawson. *They recalled it was Freddie Cook Hicks who rescued their granduncle Captain George Dow and his engineer Edward Rowe. Before long they were in touch with Osbert Hicks, son of a crewmember on the lifeboat and nephew of Freddie Cook Hicks.*

They hired a boatman named Ken to take them from Tresco to St. Agnes—the same boatman that carries schoolchildren from around the isles to St. Mary's for classes each Monday morning and returns them on Friday afternoon. They met Osbert at his home just east of Hellweathers Rocks where the T.W. Lawson *was lost and two crewmembers rescued. Osbert enthusiastically welcomed them in to his home and shared his considerable*

> "As was our custom, Father and I talked late into the night. I remember so well his closing words, 'Well, this Friday the thirteenth went off without anything going wrong.'"

Lawson *lore. He played a tape of a BBC interview his late father Jack Hicks made during the 1960s recalling the night of the sinking and the ferocity of the storm.*

Later Osbert took them to meet his cousin, Joe Hicks, who is Freddie Cook Hicks's son. Joe, in his early eighties, was not in great health. But he perked up smartly when visitors from the other side of the ocean came to hear the story of the T.W. Lawson. *Above his bed hung the photo of his father and the rest of Slippen's crew receiving their medals from a representative of the U.S. government. Joe emphasized how much his father was distraught over the fate of his own father, the St. Agnes pilot who had boarded the* T.W. Lawson *and was lost with the rest of her crew.*

They left the Scillies several days later greatly impressed by the beauty of the isles, the T.W. Lawson *artifacts displayed on Tresco and in the maritime museum on St. Mary's and the wonderful friendliness and simple lifestyle of their new acquaintances, Osbert, Joe and Ken. Somehow, being there, meeting them and seeing Hellweathers Rocks helped our family understand the last hours of the* T.W. Lawson.

The story of the T.W. Lawson, *particularly its final and fatal voyage, has attained notoriety because of the uniqueness of the ship. As descendants of a younger brother of the* T.W. Lawson's *captain, George W. Dow, the story has drawn our attention to the human factors involved in choosing a seafaring career: the love of the sea, the opportunity to make a living and the courage to face the risks involved. Many members of the Dow and Hicks families made this choice and we recognize and honor them all.*

—Quinn-Calderone families, relatives of
Captain George Dow

⚓

> "Captain Dow, master of his ship, had to decide whether to stay with or leave his ship as he was advised by the island's lifeboat men. As we all know, staying was fatal for so many."

Say the name T.W. Lawson *on St. Agnes in the Isles of Scilly and one thinks back to the very big sailing ship that was wrecked on the islands, in the tremendous storm on the night of December 13, 1907. As a son and grandson of two of the men who took part in the rescue of the only three survivors of the wreck, I feel very humble, and privileged, to have been able to assist in passing on the detail of what happened on that fateful night, and the following days, as told to me by my father.*

My thought of course, in hindsight, is that Captain Dow, master of his ship, had to decide whether to stay with or leave his ship as he was advised by the island's lifeboat men. As we all know, staying was fatal for so many.

The islanders of St. Agnes are very proud of the heroism and seamanship of the men who risked their own lives to save others. It was a pleasure to

meet relatives of the captain and talk about the wreck of the T.W. Lawson, *something that greatly affected their families, as it did mine.*

My personal thanks to Tom Hall, whom I had the pleasure of meeting on several occasions, for giving so much of his time in researching the history of the huge but ill-fated sailing ship.

—Osbert Hicks, son of Jack Hicks, St. Agnes lifeboat man

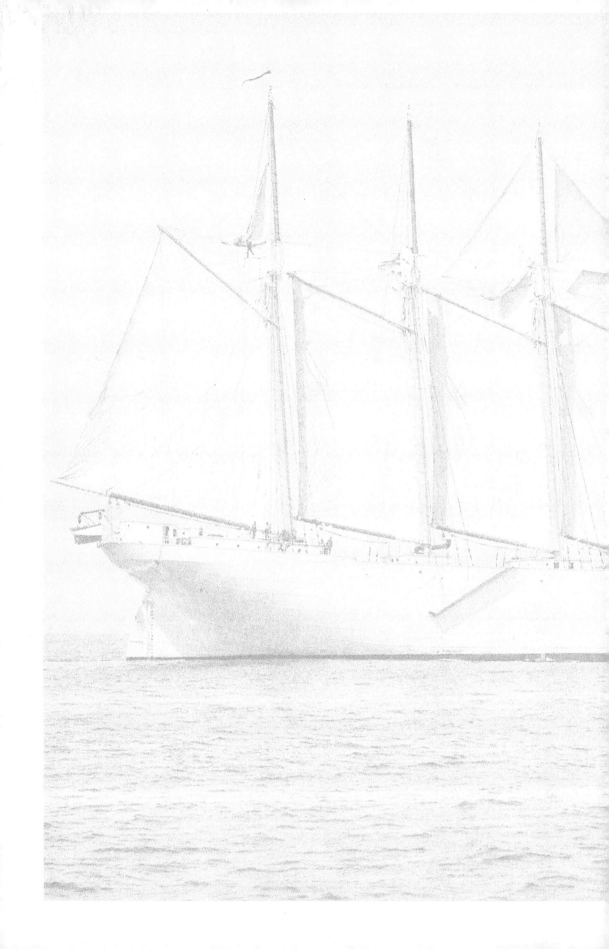

Part One

Cast of Characters

Thomas W. Lawson

Boston financier, self-made man and taker of risks. In 1901, he worked with his partners to build and run the world's first and only seven-masted schooner, the *T.W. Lawson*, which wrecked on the night of December 13–14, 1907, off of the Isles of Scilly.

Captain George Dow

Captain of the *T.W. Lawson* on her first and final transatlantic voyage in 1907. Captain Dow, from a well-known seafaring family of Hancock, Maine, was an experienced commander of large sailing ships. Captain Dow was one of two survivors of the *T.W. Lawson*'s wreck.

Engineer Edward Rowe

Veteran engineer on the *T.W. Lawson* (he righted the *Lawson* when she almost capsized in Sabine, Texas, and again in Newport News, Virginia). Rowe was, with Captain Dow, one of the two survivors of the ship's wreck.

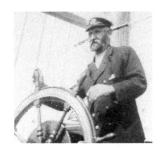

Billy Cook (Hicks)

Trinity House–licensed pilot who boarded the *T.W. Lawson* on the night of December 13, 1907, to help steer the ship to safety. Cook was a crewmember on the lifeboat *Charles Deere James* when it sailed out to the rescue of the *T.W. Lawson*. He died in the shipwreck.

Freddie Cook (Hicks)

Son of Billy Cook, on the rescue lifeboat *Charles Deere James* the night of December 13, 1907, when his father boarded the *T.W. Lawson*. The next day, he pushed for a rescue crew to go out as quickly as possible. Though he was never able to find or rescue his father, Freddie Cook and the other rescuers found Captain Dow and engineer Rowe alive in a crevice in the rocks high above the water, and it was Freddie Cook who got them both to the rescue boat.

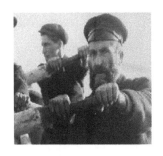

George Mortimer

Coxswain of the lifeboat *Charles Deere James* on December 13, 1907. Mortimer took the lifeboat out and offered to rescue the crew of the *T.W. Lawson*, dangerously anchored in a gale among the rocks off the island of St. Agnes, but Captain Dow declined the offer.

Bowdoin B. "Bodie" Crowninshield

Designer of the schooner *T.W. Lawson* and America's Cup challenger *Independence*. A member of the foremost family of naval architects from Marblehead, Massachusetts, "Bodie" specialized in small racing schooners and fishing boats. He was in his mid-thirties when work began on the *T.W. Lawson*.

John and Arthur Crowley

Partners with Lawson and Crowninshield in the vision and building of the schooner *T.W. Lawson.* John Crowley ran the Coastwise Shipping Company; Arthur Crowley captained the company's bigger ships, including the *T.W. Lawson* schooner (though he was not the skipper for its only transatlantic voyage in 1907).

George Allen

The only English sailor on the *T.W. Lawson* and the only person found alive on the shore of Annet Island, along with the mangled bodies and body parts. George Allen did not survive his wounds.

First Mate Bent P. Libby

Sailor called out of retirement by Captain Dow for the *T.W. Lawson*'s transatlantic voyage. Libby had retired from sea life to work in Boston and raise a family but sailed on this voyage as a favor to Captain Dow. He did not survive the wreck.

Mark Groves

Master diver and owner of Nowhere Dive Shop on the Isles of Scilly. It was Groves who discovered the *Firebrand*, one of Sir Cloudesley Shovel's ships wrecked in 1707. Mark took me down to the wreck of the *Lawson*, off the uninhabited island of Annet.

Thomas Hall

Me. I grew up in Scituate, Massachusetts, where Thomas W. Lawson had his family estate, Dreamwold, and planned the building of his visionary but doomed seven-masted schooner.

It's been satisfying and thrilling for me to dive on the wreck and spend time in the Isles of Scilly, where I've become friends with many of the islanders.

Alec Collyer

Underwater photographer. Collyer put together the film that the BBC made about the wreck of the *T.W. Lawson* and our dives on the wreck itself. Alec has also come to the States and helped give lectures and slide shows about the *Lawson* and the disaster.

Osbert Hicks

Son of Jack Hicks and grandson of the Osbert Hicks who was part of the rescue mission on Saturday morning, December 14, 1907. Osbert Hicks the grandson lives in the old family house on St. Agnes and travels all around the Isles of Scilly by boat. He was very generous to me with his time and with information, stories and memories of the wreck of the *Lawson* and other island history.

TIMELINE

1514 Trinity House is incorporated to regulate and license pilots in London and forty districts, including the Isles of Scilly.

1680 King Charles II gives Trinity House power and license to erect and maintain lighthouses on the Isles of Scilly.

1707 Sir Cloudesley Shovel wrecks four of his ships and loses two thousand men on the Western Rocks off the Isles of Scilly.

1824 Royal National Institution for the Preservation of Lives from Shipwreck is founded in London (name changed in 1850 to Royal National Lifeboat Institute).

1848 George W. Dow is born in Hancock, Maine.

1857 Thomas W. Lawson is born in Charlestown, Massachusetts; Billy Cook (Hicks) is born on the island of St. Agnes in the Isles of Scilly. Both Bishop's Light in Scilly and Minot's Light in Scituate are reconstructed of solid granite after being wrecked in storms.

1882 Billy Cook (Hicks) gets his Trinity House pilot's license.

1887	Freddie Cook (Hicks) is born on St. Agnes, Isles of Scilly. Current structure of Bishop's Rock Lighthouse is completed, to final height of 167 feet.
1888	701-ton *Bernardo* wrecks off Annet Island in the Isles of Scilly in a huge west-northwest gale.
1901	Keel is laid in November for seven-masted schooner *T.W. Lawson*.
1902	Schooner *T.W. Lawson* is rigged and launched July 10; the *Lawson* starts sailing along the U.S. Atlantic coast; Lawson Tower completed in Scituate.
1904	Lifeboat *Charles Deere James* goes into service at the new lifeboat station on St. Agnes Island in the Isles of Scilly.
1906	Coal rates drop, making the *T.W. Lawson* less profitable; the schooner is refitted to handle bulk liquids. Thomas Lawson's wife Jeanne, the love of his life, dies. Friends say Lawson is never the same again.
1907	Captain George Dow takes command of the schooner; the *T.W. Lawson* is prepared for a transatlantic trip.
November 6	Captain Dow arrives in Marcus Hook with his officers.
November 17	Six *Lawson* crewmembers quit in a pay dispute, to be replaced by, essentially, stragglers on the dock.

| November 19 | Schooner *T.W. Lawson* is loaded with two and a quarter million gallons of light oil in Pennsylvania and sails for London with Captain Dow and a total crew of eighteen. |
| November 19– December 13 | The *T.W. Lawson* takes twenty-five days to make a transatlantic trip that should have been possible in fifteen. The ship is battered by three gales on the crossing, ripping all but six of its sails, splintering all three life rafts and exhausting the crew. |

Friday, December 13

Early afternoon	The crew of the *Lawson* sights Bishop's Rock Lighthouse. Captain Dow drops anchor.
2:00 p.m.	Keepers of Bishop's Rock Lighthouse, sighting the *Lawson* anchored among the rocks, send off a flare; a lifeboat crew starts assembling on island of St. Agnes.
4:00 p.m.	Lifeboat *Charles Deere James*, from St. Agnes, is launched, reaching the *T.W. Lawson* at 5:00 p.m. to offer rescue; Captain Dow declines but takes Trinity House pilot Billy Cook aboard. Lifeboat and crew tie up astern of the *T.W. Lawson*.
4:30 p.m.	Lifeboat *Henry Dundas*, from St. Mary's, is launched, reaching the *T.W. Lawson* at 5:30 p.m. It is pushed and thrown repeatedly against the ship and its mast breaks. After warning Captain Dow of the dangerous position, the crew of *Henry Dundas* returns damaged to St. Mary's at 7:00 p.m., promising to telegraph for the steamer *Lyonesse*.

10:00 p.m.	Lifeboat *Charles Deere James* returns to St. Agnes to care for a sick crewmember; Billy Cook remains onboard the *T.W. Lawson*.
Sometime in the night of Friday– Saturday	Two tugboats and the steamer *Lyonesse* receive a telegraph that the *Lawson* needs help, but all are forced to return to Falmouth because of the storm.
Saturday, December 14	
1:00 a.m.	Lifeboat crew on St. Agnes meets in the old lighthouse and sights *T.W. Lawson*'s riding lights, steady and holding.
1:15 a.m.	Under pressure from tide and waves, the *T.W. Lawson*'s port anchor snaps, followed thirty minutes later by the starboard anchor; the ship hits bottom fifty yards from Shag Rock. In the following minutes and hours, the ship is broken and the masts are thrown into the water.
1:50 a.m.	In lighthouse on St. Agnes, Freddie Cook notices that the ship's riding lights are no longer to be seen. George Mortimer, lifeboat coxswain, refuses to take the lifeboat out again on a dangerous and maybe unnecessary mission.
7:00 a.m.	The gig *Slippen* is launched off St. Agnes to investigate and possibly rescue crew from the *Lawson*; the ship is found upside-down and sinking, surrounded by oil and mangled bodies. One survivor (George Allen, who later dies) is found on the shore of uninhabited Annet Island.
2:30 to 7:00 p.m.	The crew of the *Slippen* finds two men wedged in a crevice in the rocks high above the water; from mid-afternoon until sunset, Freddie Cook and the crew of the gig *Slippen* rescue both of them. They are Captain Dow and engineer Edward Rowe.

FROM THE AMERICAN SIDE

Thomas W. Lawson (the Man)

Thomas William Lawson was born in Charlestown, Massachusetts, in 1857. He was the only boy in a family of four children, and when his father died in the Civil War, Thomas felt the responsibilities of being the man of the house. At age twelve he skipped school and convinced a local banker to hire him to count money; his mother canceled the arrangement later that afternoon, reminding the banker that Thomas had obligations at school. Lawson made and lost $60,000 before he was seventeen, and $1 million before he was twenty-one.

By the turn of the century, Lawson's estimated wealth was over $25 million, some estimations going as high as $60 million, making him one of the richest men in America. A successful financier and stock trader, his biggest deal was a partnership with Standard Oil to corner the copper market in 1897. When the partnership's stock went public it soared but then crashed, and Lawson, anxious to restore his reputation, wrote a series of books and articles over the next decade—with titles such as *Frenzied Finance* and *Friday the Thirteenth*—to explain himself to the furious investors who'd lost in the deal, arguing that Standard Oil, not Thomas Lawson, was to blame for the copper scandal.

Lawson was bold and superstitious at once, taking risks, acting quickly, but avoiding deals on unlucky days and filling his house with good luck charms. When his wife admired the sea views in Scituate, Massachusetts, he built her an estate there within a year and made it into the most famous country estate in the United States, complete

> Lawson was bold and superstitious at once, taking risks, acting quickly, but avoiding deals on unlucky days.

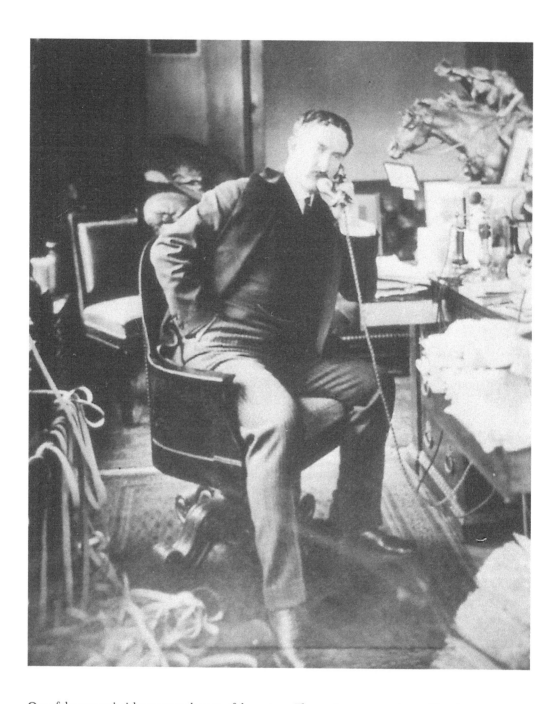

One of the country's richest men at the turn of the century, Thomas Lawson was also a self-made man. He made and lost $60,000 before he was seventeen and $1 million before he was twenty-one. Once, after a particularly bad day, he took his friends out to dinner and blew his last hundred dollars on a nice dinner and a fine tip for the waiter.

For Lawson, the risk-taker and opportunity-grabber who seemed to think nothing of spending $30,000 to buy the rights to a carnation his wife admired, and who carried a $10,000 lucky watch, the seven-masted schooner he built with his partners was another bold move and moneymaking venture all at once.

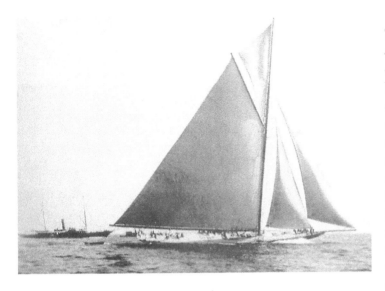

Thomas Lawson's office above Boston harbor looked out on steam colliers, fishing boats, ships and schooners: a bustle of commercial boats and ships. And of course the schooner *T.W. Lawson* was designed and built to make money from start to finish. But Lawson was more than just a financier. He was a mariner in his own right, and his steam sailor *Dreamer* was often seen up and down the coast between Boston and New York. The *Dreamer* is in the background aft of the Independence, the America's Cup racer designed by Lawson and B.B. Crowninshield.

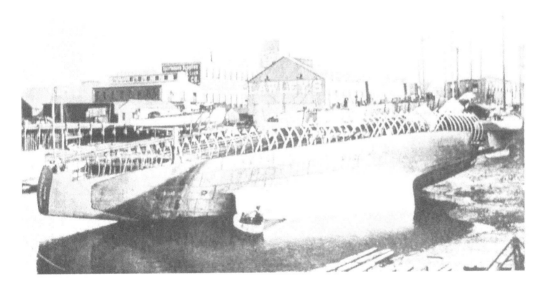

The *Independence* was not allowed to represent the United States against the challenger Sir Thomas Lipton and his *Shamrock II* because Lawson was not a member of the New York Yacht Club. Even if allowed, however, the *Independence* proved to be a leaky, unreliable racer during the summer trials, probably because it was built too quickly.

Unwilling to disavow his membership in the Hull, Massachusetts Yacht Club to satisfy the arrogance of the New York Yacht Club, Lawson ran the *Independence* aground at the end of the summer and had it taken apart plank by plank. The press on both sides of the ocean applauded his courage (and his eccentricity) and called for a special race between the *Copper King* and the *Tea King*. That race never happened.

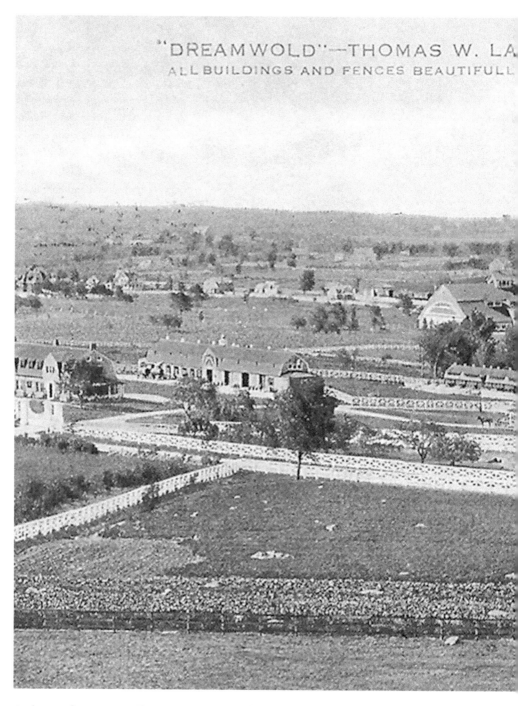

At the age of twenty-one, Thomas Lawson married his high school sweetheart, Jeanne. On a Sunday excursion in 1899, Jeanne admired the beautiful sea views of Scituate, Massachusetts, just south of Boston; soon after, the Lawsons were building their family estate of Dreamwold there. In less than a year, Dreamwold would become the most famous country estate in the United States. Dreamwold was complete with world-class pedigrees, thoroughbreds, racetracks and riding stables. There were also birdcages, duck ponds, electricity and phones—Dreamwold even had its own post office and fire brigade.

Lawson, bold and assertive in everything he undertook, believed in the winged horse Pegasus, with its motto of "Beauty, Strength, and Speed." When Lawson was building Dreamwold, he would say: "If a four-by-six works, make it a six-by-eight." When the town water tank obstructed his view, he built a replica of a fifteenth-century German castle around it. Feeling patriotic, he had the largest flagpole in the United States installed on the front lawn: the flagpole was 172 feet tall and flew a flag 50 by 72 feet. And in order to get from his estate in Scituate to his office in Boston faster, he convinced the Old Colony Railroad to make a special stop at Dreamwold, and then run non-stop from there to Boston (the non-stop run was thirty-seven minutes).

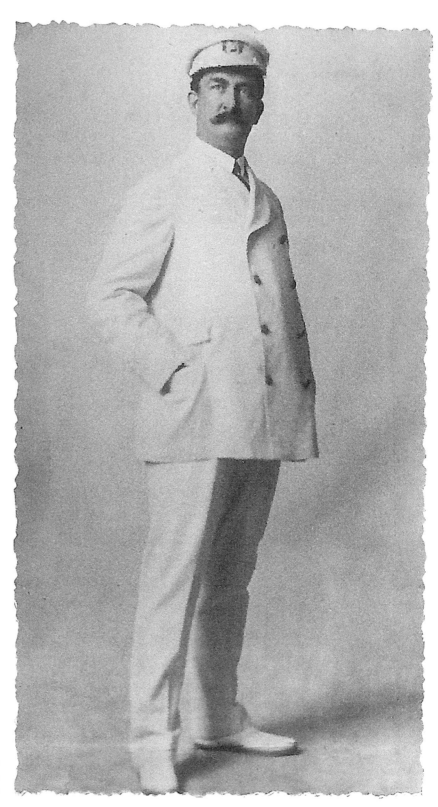

Thomas W.
Lawson,
mariner.

with world-class pedigrees, thoroughbreds, race tracks, riding stables, bird cages, duck ponds, electricity, phones and even its own post office and fire squad. When she admired a particular carnation, he bought the rights to it for $30,000 and renamed it the Lawson Carnation. Their house was filled with elephants, which Lawson believed were good luck charms. Lawson only bought stocks in lots of 333 or 3,333 (he thought the number 3 was lucky), and he carried his lucky watch (that he had designed himself) everywhere he went. But he feared Friday the thirteenth and never traded stocks on that date.

In 1901 the America's Cup racer *Independence*, designed by Lawson with B.B. Crowninshield of the famous family of naval architects, was barred from racing in the America's Cup because Lawson was not a member of the New York Yacht Club. Lawson ran the *Independence* aground at the end of the summer and had it taken apart plank by plank (making headlines on both sides of the ocean), rather than disavowing his membership in the Hull, Massachusetts Yacht Club to satisfy the demands of the New York Yacht Club. But even before the *Independence* was taken apart, the keel had been laid for another boat designed by Lawson and Crowninshield: the world's first and only seven-masted schooner, the *T.W. Lawson*.

Thomas Lawson designed a watch for himself that would chime fifteen minutes before the start and close of Wall Street trading. It also chimed the hour and had a fancy arrangement of chimes that marked the time down to the minute. Tiffany made the watch for him for $10,000, and Lawson carried it with him wherever he went, considering it to be his lucky watch.

When struggling with the design of the seven-masted schooner one early morning in 1901, Lawson pulled the lever on his watch. It chimed six times. Fearing this was an omen warning against his seven-masted schooner, he quickly called Crowninshield to have the design of the *T.W. Lawson* changed from seven masts to six. But Lawson was overruled, and the schooner was of course built as a seven-master. To his last day, Lawson regretted that he hadn't insisted on changing the number of masts.

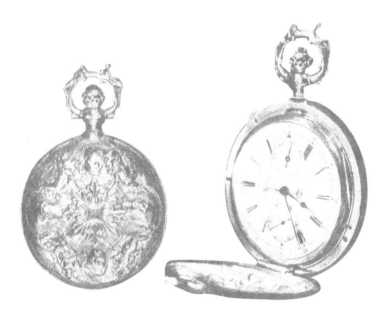

The Vision for the *T.W. Lawson*

At the dawn of the twentieth century, people were in awe of the wonderful new technologies entering their lives. You could light your home with magic electric lights, drive an automobile across town to visit a friend or, even more magically, call up your friend on the telephone. On the oceans, huge steel ships were hauling goods up and down the coast, using advances in metal, propellers, engines and steam and liquid fuel technology. There was even a new "wireless" phone that let ships communicate with each other and the coast while at sea.

Life was good for most Americans and especially good for Lawson, with his large family happy and healthy, his vast country estate in Scituate nearing completion and his wealth greater than ever. In his office above Boston Harbor, Lawson could look out the window and see steam colliers, fishing boats, ships and schooners, loading and offloading freight and making money for their owners. Lawson didn't want just a piece of the action. He wanted all of the action, and he wanted it in a way that was bolder, different and more profitable than anything done before. Lawson would break new ground, building the world's first and only seven-masted schooner, able to haul massive freight and powered by wind alone.

> But a seven-masted schooner with no other means of propulsion, when steamships were being built faster, larger and more durable? It sounded crazy.

Why a seven-masted schooner? That alone would have been a new and bold idea. Since first launched in Gloucester in 1713, with their fore and after rigging "schooning" across the bay, schooners had steadily increased in size and number of masts. But a seven-masted schooner with no other means of propulsion, when steamships were being built faster, larger and more durable? It sounded crazy. But Lawson, Crowninshield and their partners the Crowley brothers were sure that by taking advantage of changing construction techniques and materials and evolving merchant marine conditions, they could make money on their schooner in the industrial boom. It didn't bother them at all that it would be a one-of-a-kind ship; they wanted to be watched carefully—even envied—by every mariner, merchant and investor.

Evolving Merchant Marine Conditions

American ships trading around the world in 1900 were at a great disadvantage: American-built vessels were very expensive, American seamen commanded high wages and manning regulations required the ships to maintain large crews, even when labor-saving machinery and gear meant that the ships could have been run with far smaller crews. In competition with ships from other countries, American merchants were in danger of being driven out of business by their much higher costs of doing business.

But as Thomas Lawson and his partners were planning their new schooner, there were beneficial changes on the horizon. Lawson would have been well aware, for instance, that after the recent defeat of the Spanish in the Spanish-American War, America was thinking about taking over the governing of the Philippines and bringing the islands under the protection of U.S. coastal shipping laws. The Philippines accounted for annual trade of around $40 million at the turn of the century, mostly in products like hemp; the United Kingdom controlled half of that trade, while the United States had no more than a fifth. But under laws reserving trade with America to American ships, if the Philippines were made a United States territory and eventually a state, merchants from the United Kingdom and elsewhere could be effectively excluded from the Philippine trade, sheltering American merchants from international competition there.

Another opportunity for beneficial change for American merchants was in the potential relaxation of manning requirements. At the time, a large ship trading around the world was typically required to carry a crew of thirty-five to forty men, even though advances in machinery and steam would have meant that a crew of less than half that size could have worked the ship perfectly well. At $30 per man per month, trimming twenty men off the crew would mean saving $7,200 a year—enough to make an important difference in the profitability of a ship.

Knowing its planners believed that laws favoring American merchants in the Philippines and relaxed regulations allowing smaller crews in international trade were soon going to be in effect, the vision for the schooner *T.W. Lawson* perhaps doesn't seem so absurd.

As Thomas Lawson and his partners were planning their new schooner, there were beneficial changes on the horizon.

Changing Construction Techniques and Materials

The Crowley brothers. John (top) ran the Coastwise Shipping Company, while Arthur (below) captained the larger ships they owned, including the *T.W. Lawson*.

Lawson's vision also involved using advanced design and manufacturing techniques to make the ship as profitable as possible. In building the *T.W. Lawson*, he and his partners would take advantage of new steel materials and other construction techniques to make the ship more cavernous, more cost effective and stronger than it could have been with earlier technologies. To begin with, the new schooner would be longer and have greater sail area and more masts than any other ship. By relying on wind power only, and no other form of propulsion, the designers freed up the amount of space normally reserved for coal to heat the boilers on a steam-powered ship. Generally one-third of the ship's hold, that space would now be available for moneymaking cargo, increasing the ship's potential profitability by over 30 percent.

New technology would also make the *T.W. Lawson* more efficient in its manning requirements. The use of steam-assisted winches—so-called "donkey engines"—to hoist its twenty-five sails meant that only one or two sailors would be needed per mast. Two vertical boilers, fore and aft, about five by nine feet each, would furnish the steam to power the anchor windlass, steering unit, five sail-hoisting engines, two drainage pumps and a variety of other engines for hoisting cargo. The machinery would be arranged so that only two engineers were required onboard to work it, and most of the time only one would be needed. Sails on the *Lawson* could be changed in one-third the time it would take on a square-rigger of similar size, and with the donkey engines and efficient machinery arrangements, the *Lawson*'s total manning requirements would only come to sixteen to eighteen men.

Finally, at the turn of the century ship and railroad builders were beginning to take full advantage of the tremendous advances in steel production made over the past fifty years. Although steel has been known and in use for centuries, its production was extremely limited until the invention in the 1850s of the Bessemer process, which forces air through a bath of molten iron, and improvements to the open-hearth process a decade later. These advances produced steel with lower carbon content, usually less than 1 percent, and a modern metal generally more malleable, tougher and less brittle than iron.

B. B. CROWNINSHIELD

NAVAL ARCHITECT
Brokerage &
Marine Insurance

Cable Address, "PIRATE BOSTON."

31 State Street.

Boston. December 19, 1901.

It is mutually agreed that the commission received for the de-
signing and superintending the construction of the seven-masted schoo-
ner for Captain John G. Crowley is to be given in part payment for
a sixty-fourth of said vessel and that the balance is to be paid for
by B. B. Crowninshield, and that the said sixty-fourth share is to be
his personal property.

It is also mutually agreed that said Crowninshield is to pay to
Frank N. Tandy his interest of the above mentioned commission when
the vessel is completed and ready for sea.

It is further mutually agreed that up to the 20th of September,
1901, the date of our dissolution of partnership, that eighteen twenty-
fifths of the work of designing the seven masted schooner had been
completed and eighteen hundred dollars ($1800) of the total Twenty-
five Hundred Dollars commission had been earned, and that said Tandy's
one-third share of the money earned to September 20th, 1901, amounts
to Six Hundred Dollars ($600), which is six-twenty-fifths part of the
total commission.

It is further mutually agreed that if said Crowninshield sells
his sixty-fourth share in said schooner before she is ready for sea,
for more or less than the actual cost as called for by said Crowley,
the difference is to be added or subtracted, as the case may be, from
amount of said commission, and that said Tandy is to receive his six
twenty-fifths part of said commission.

Witness our hands this 19th day of December, 1901.

B. B. Crowninshield

Frank N. Tandy

Seen here is the contract detailing $1/64$ ownership of the *T. W. Lawson* by the designer B.B. Crowninshield,
which was common among shipbuilders. Note the cable address of "Pirate Boston!"

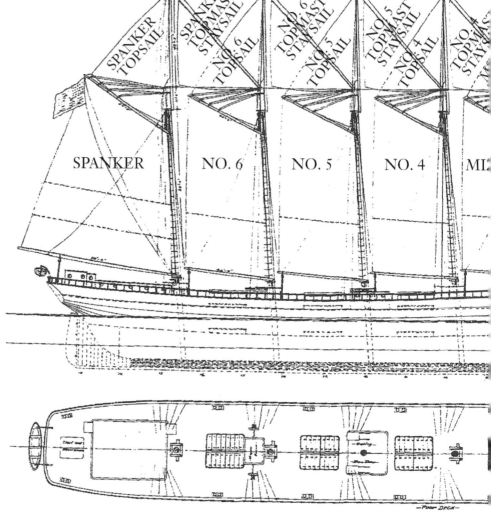

Labels on sails (from left to right): SPANKER TOPSAIL, SPANKER TOPMAST STAYSAIL, NO. 6 TOPSAIL, NO. 6 TOPMAST STAYSAIL, NO. 5 TOPSAIL, NO. 5 TOPMAST STAYSAIL, NO. 4 TOPSAIL, NO. 4 TOPMAST STAYSAIL

SPANKER NO. 6 NO. 5 NO. 4 MI

—Poop Deck—

NAME: THOMAS W, LAWSON HULL 110
BUILT BY: FORE RIVER SHIP & ENGINE COMPANY
OWNED BY: COASTWISE TRANSPORTATION COMPANY
LOA: 404'–LBP: 368'–BEAM: 50'–DEPTH: 32'
GROSS TONNAGE: 5,218 TONS–DISPLACEMENT: 10,860 TO

B.B. Crowninshield, the seven-masted schooner's young designer, was inexperienced in large ship design. His family had been building ships in Boston for over a century, but Crowninshield himself had until this project focused on smaller racing sailboats like the *Independence* and fishing boats. Crowninshield seems to have impressed Thomas Lawson enough that he was tapped to handle the unprecedented seven-masted schooner project.

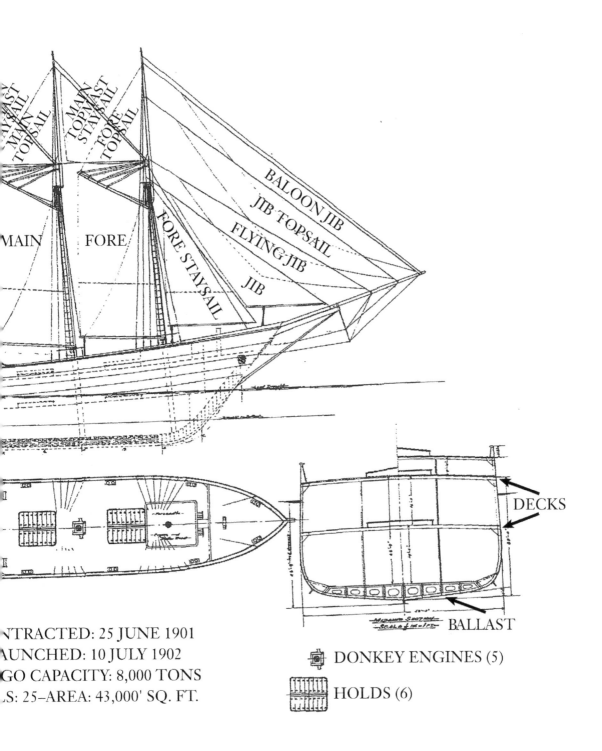

BALOON JIB

JIB TOPSAIL

FLYING JIB

JIB

FORE STAYSAIL

MAIN

FORE

MAIN TOPSAIL STAYSAIL FORE TOPSAIL

MAIN TOPSAIL

DECKS

BALLAST

NTRACTED: 25 JUNE 1901

AUNCHED: 10 JULY 1902

GO CAPACITY: 8,000 TONS

S: 25–AREA: 43,000' SQ. FT.

DONKEY ENGINES (5)

HOLDS (6)

Crowninshield's design evolved throughout the building process, as most ship designs do. For instance, the plans originally included beakhead carvings and headrails, but those plans were dropped as the project progressed and with them, according to Erik Ronnberg, a chronicler of the ship's construction, the *Lawson* seems to have lost its last chances at the beauty of a traditional clipper or wooden schooner. Decisions about the bottom line trumped questions of aesthetics as the shipbuilding project progressed.

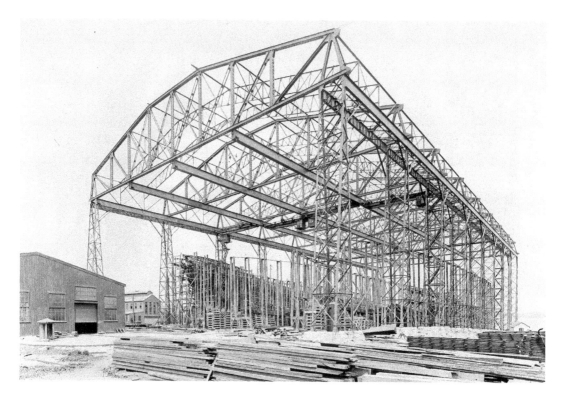

Lawson in a construction basin with framing complete and plates being installed.

The economy of steel construction would mean that the ratio of cargo the ship could carry to its hull weight, at 3 to 1, was among the highest of any at the time. And the ship's low manning requirements and high gross registered tonnage (over 5,200) meant that each crewman could cover 325 tons, twice the gross tonnage per needed man of a steamship or regular square-rigged sailing ship.

Lawson and his partners certainly had reasons to believe that their unprecedented schooner would make money. The plans for their new vessel were perhaps strange looking and in some ways backward-seeming (in the decision not to provide any auxiliary means of propulsion, for instance), but taken together, the ship made financial sense.

Building the Schooner

At the time the schooner *T.W. Lawson* was being planned and built, Lawson, though tremendously wealthy and respected, was trying to restore his reputation in the wake of the copper scandal.

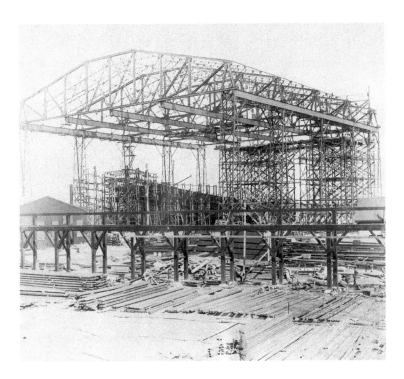

The *T.W. Lawson* was built at the Fore River Ship and Engine Company of Quincy, Massachusetts, fifteen miles south of Boston. Founded by Thomas Watson in 1887, the shipyard was known for quality and expertise in steel construction; the *T.W. Lawson* in 1901 was the shipyard's biggest project to date.

At the shipyard, the great ship was first framed with angle stock, pre-punched for rivets and worked to shape with heat, pins and levels. The hull plating was applied in strakes, following the usual in-and-out pattern for steel hulls, with joggled outer plates. The frames and plates were all pre-punched and riveted together; the rivet holes had to match the holes in the plates every time, without benefit of prior fitting for hole alignment.

He had also just recently completed the building of his nationally famous family estate, Dreamwold, in Scituate, and was ready for a new project to take on. It was Lawson who financed the lion's share of the schooner project.

Bowdoin B. "Bodie" Crowninshield, ten years younger than Thomas Lawson, was inexperienced in large ship design when Lawson hired him to work on plans for the schooner. Even though his family had been building ships in Boston for over a century, his own focus before working on the seven-masted schooner had been on small racing sailboats and fishing boats (including Lawson's fast sailboat *Independence*). It is a testimony to Lawson's high opinion of him, and what is more, his willingness to bet on that high opinion, that this young designer was asked to work on the seven-masted schooner.

Lawson's other partners were John and Arthur Crowley of the Coastwise Shipping Company. Experienced and successful, the Crowley brothers had been in the shipping business for many years, building big ships such as the six-masted wooden schooner *George Wells*. John Crowley ran the company while Arthur captained the bigger ships; he would captain the *T.W. Lawson* for most of its five years of operation, as well. Thomas Lawson had been dealing with the Crowley brothers for years in the coal business around Boston and had great respect for them.

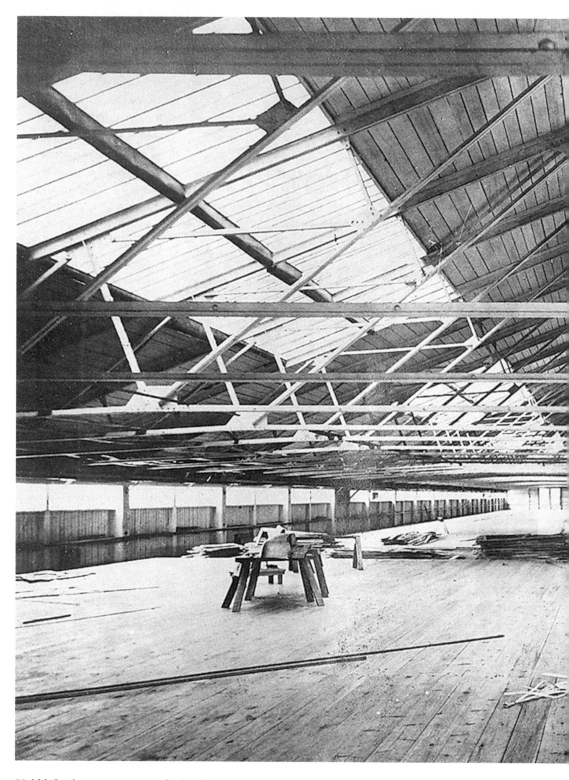

Mold loft where patterns were finalized.

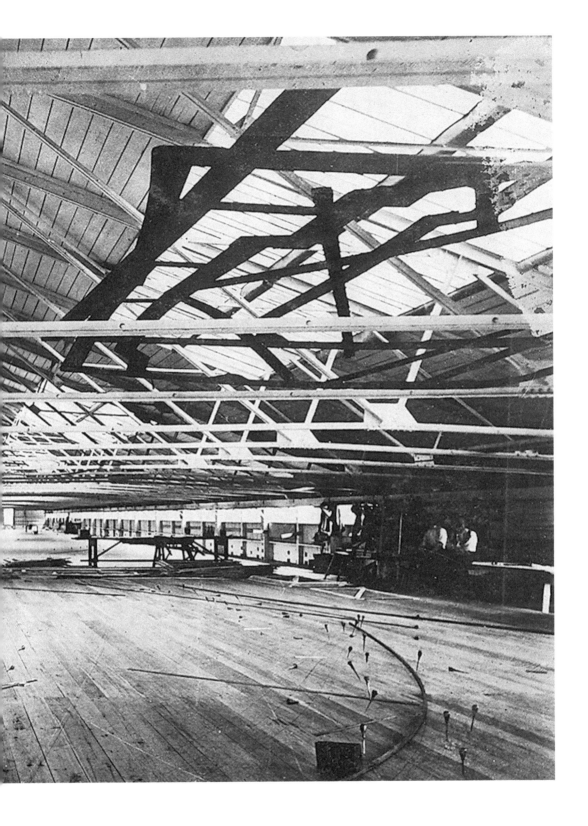

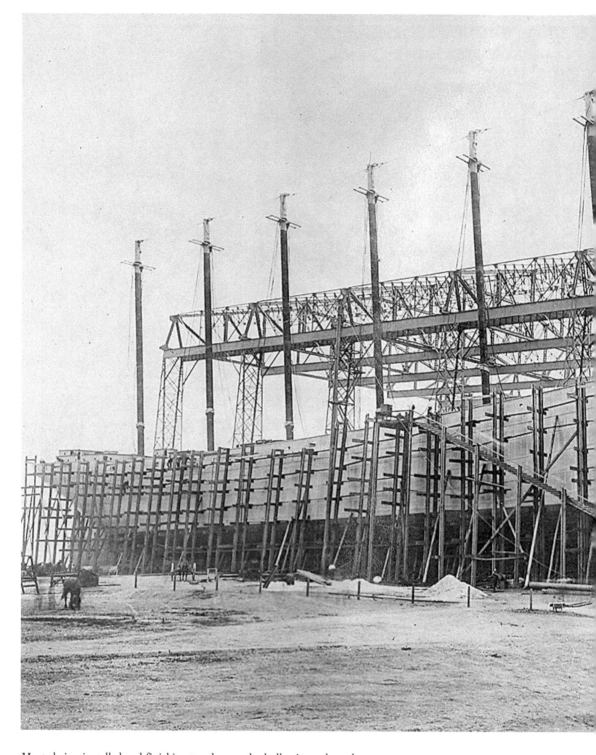

Masts being installed and finishing touches on the hull prior to launch.

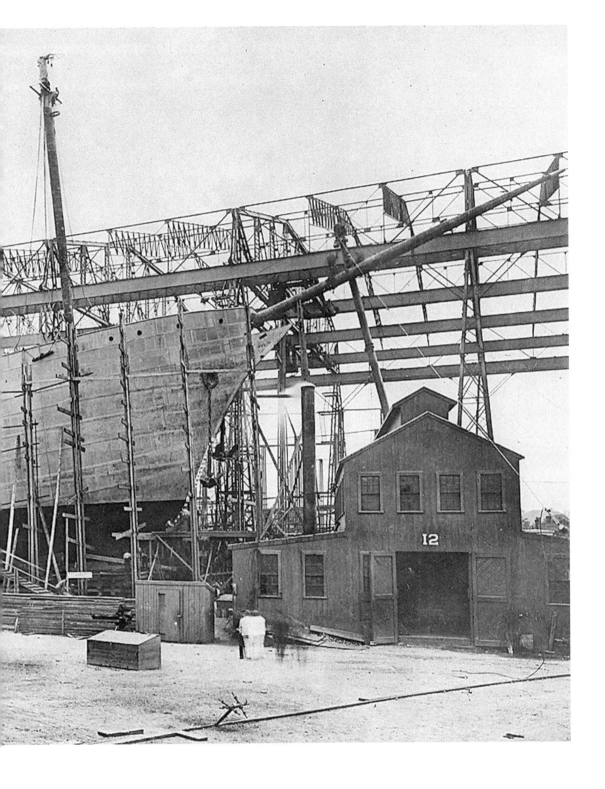

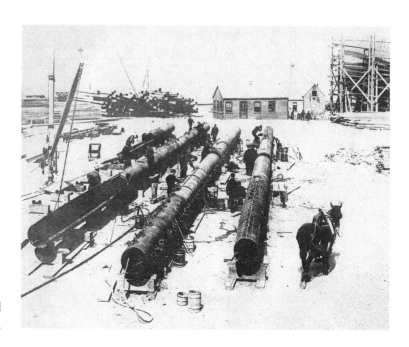

Lower masts being riveted together.

The contract for the *T.W. Lawson* was signed in June of 1901, with the keel laid shortly after. Assigned hull number 110, the great ship was built at the Fore River Ship and Engine Company of Quincy, Massachusetts, a small yard fifteen miles south of Boston known for quality and expertise in steel construction. The shipyard was started by Thomas Watson, famous for his assistance to Alexander Graham Bell; Watson felt there was more opportunity in shipbuilding than in phones.

In 1901, the *T.W. Lawson* was the shipyard's tenth and biggest project to date. That honor didn't last long, as the shipyard soon afterward built two slightly longer battleships, the *New Jersey* and the *Rhode Island*, both of which fought for many years with distinction.

The construction techniques in use at the shipyard had to be perfect. According to Erik Ronnberg, who wrote the definitive analysis of the *T.W. Lawson*'s construction entitled *Stranger in Truth Than in Fiction*, the ship was "first framed with angle stock, pre-punched for rivets and worked to shape with heat, pins and levers. The hull plating was applied in strakes, following the usual in-and-out pattern for steel hulls, with joggled outer plates. The frames and plates were all pre-punched and riveted together; the rivet holes had to match the holes in the plates every time, without benefit of prior fitting for hole alignment. It is a testimonial to the high quality of workmanship at the shipyard that they could stay in business using these unforgiving techniques."

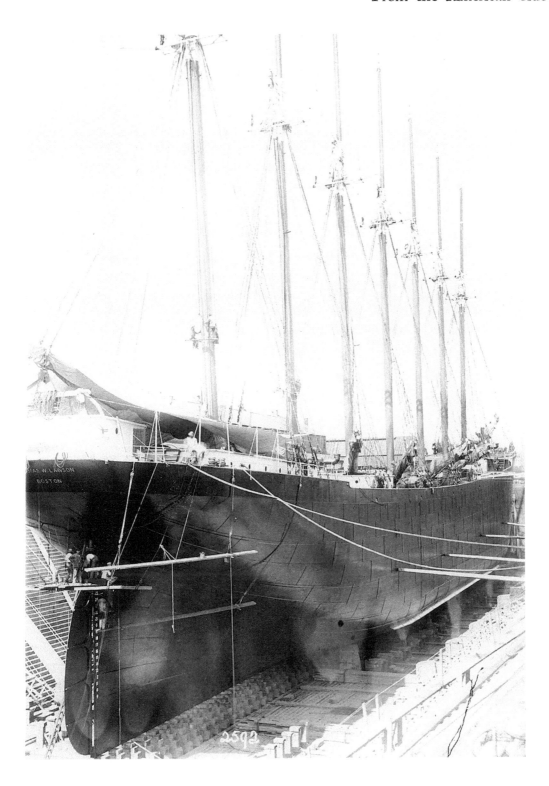

Lawson in drydock; notice large stern overhang.

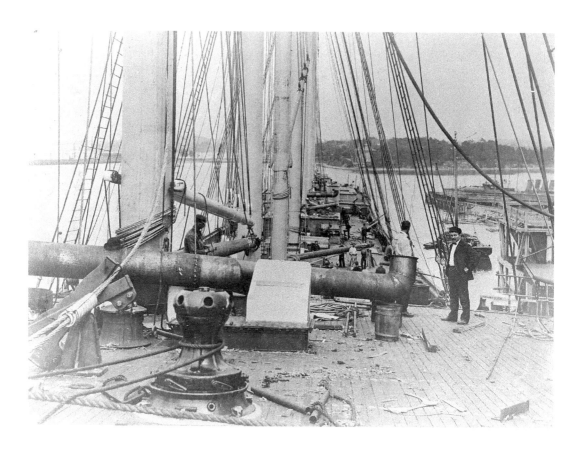

Note horizontal boiler exhaust on deck. Possibly Arthur Crowley looking on.

Hull designs for most ships evolve as they are being built and the *T.W. Lawson* was no exception. Design changes made on the schooner along the way reflected the need to launch quickly and begin making money, the fact that new steel construction techniques and materials continued to emerge and the realization that market forces were changing. The less stringent manning requirements and international regulations Lawson had hoped for were not, after all, coming to pass. The demand for coal in the United States, on the other hand, was booming. Looking back at the process, if we compare carefully the seven-masted schooner's plans at the beginning and at the end of construction, it seems clear that Crowninshield, Lawson and the Crowley brothers were struggling with all of these issues and designing on the fly.

The *T.W. Lawson* started out looking like a steel version of a conventional wooden coastal schooner. By the end, it more closely resembled the steel hulls of a modern oil tanker. Crowninshield's final design focused primarily on cargo capacity and utility rather than classic lines and aesthetics. The ship's bow made a very full entry, while its stern was wide and elliptical; the overall length

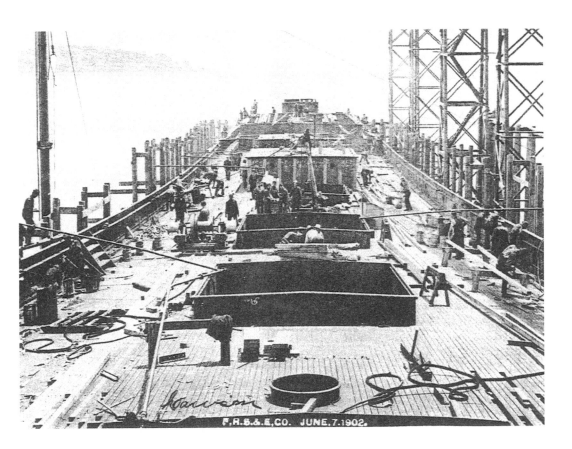

F.R.S.&.S.CO. JUNE,7.1902.

Deck being laid just prior to launch; note mast collar and large hatches.

grew to 404 feet, with a depth of 32 feet loaded and 12 feet in ballast. Interestingly, though, the *Lawson* retained the maximum beam width of 50 feet traditionally used in British wooden ships. With 368 feet along the waterline, her hull speed was roughly twenty-six knots.

According to Ronnberg, "Any hope of the *Lawson* retaining the beauty of a traditional clipper or wooden schooner was dashed when planned beakhead carvings and headrails were dropped." Built for maximum profitability, the *T.W. Lawson* became the first "super" tanker in function and in look, appalling traditionalists who viewed the ship as one ugly sailing barge.

The ship was cavernous by the standards of the day, with two complete decks, a tier of widely spaced hold beams and six large hold openings on the deck. It was also luxurious for its time, with a telephone circuit connecting the wheelhouse with the forward and after engine rooms, an electric plant to light the entire ship with incandescent lighting and steam heat in the crew's berths (a real luxury). In addition to the machinery that made it so much easier and quicker to raise the sails, the

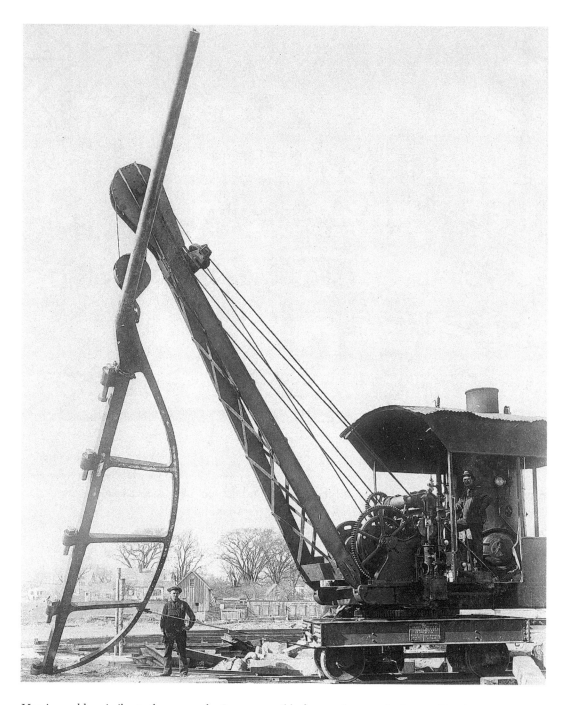

Massive rudder, similar to the one on the *Lawson*, possibly from a six-masted schooner *Douglas*.

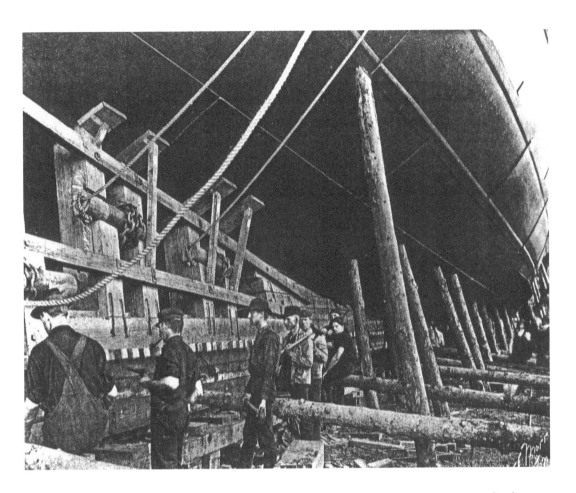

T.W. Lawson on the slipways at the Fore Rover Ship and Engine Company, Quincy, Massachusetts, just prior to launch, July 10, 1902.

Lawson had a poop extending well forward of the after mast, a topgallant forecastle above the windlass and high bulwarks to keep everyone dry. Aft over the rudder a wheelhouse, with colorful green trim, protected the helmsman in all kinds of weather while he operated the steam-assisted steering unit. The use of machinery not only reduced the number of crew required, but it also vastly improved convenience and safety for the crew. According to Axel Larson, first mate on the *T.W. Lawson* for many years, though not on her final cruise, "She was the most comfortable sloop on the coast."

Of course, it was the seven masts that made the *T.W. Lawson* unique. The lower masts were steel; the topmast gaffs and booms were wood. The lower steel masts—135 feet long, 32 inches in diameter and nearly 20 tons each with the rigging included—were riveted together. The pine topmasts were 58 feet long and shaped in the traditional manner. From deck to topmast the *Lawson* measured a soaring 155 feet; from the

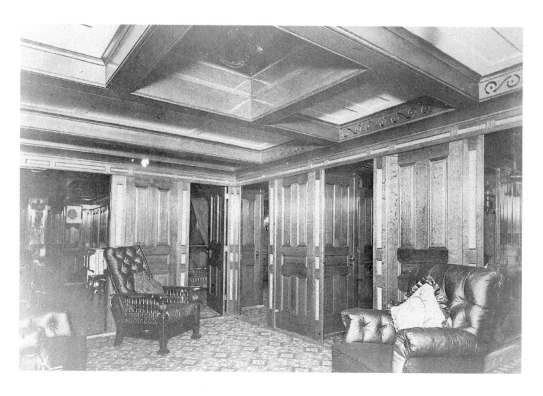

Above: Salon of the *Lawson*. Note leather chairs, carpet and paneling. *Below:* Captain's stateroom with leather couch and electric lights.

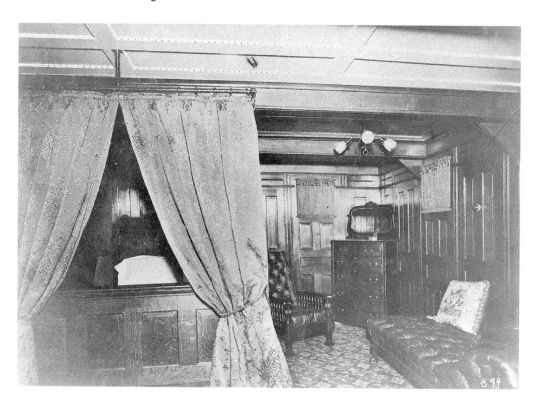

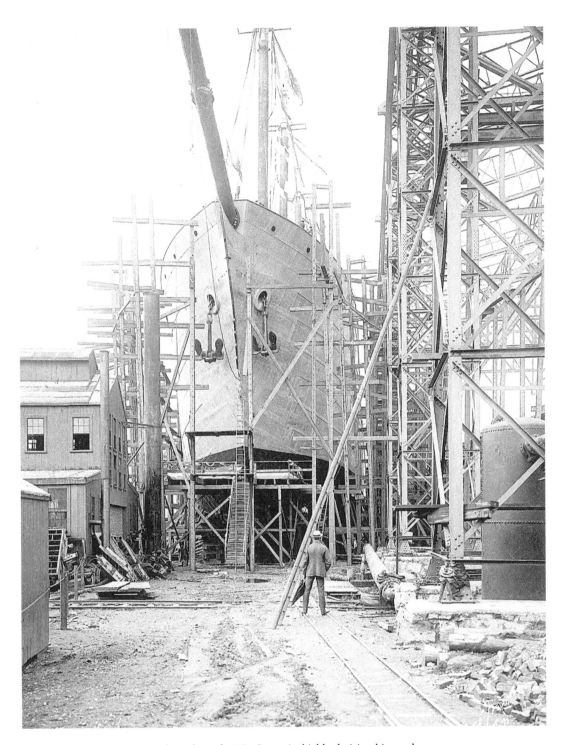

The *T.W. Lawson* just prior to launch, with B.B. Crowninshield admiring his work.

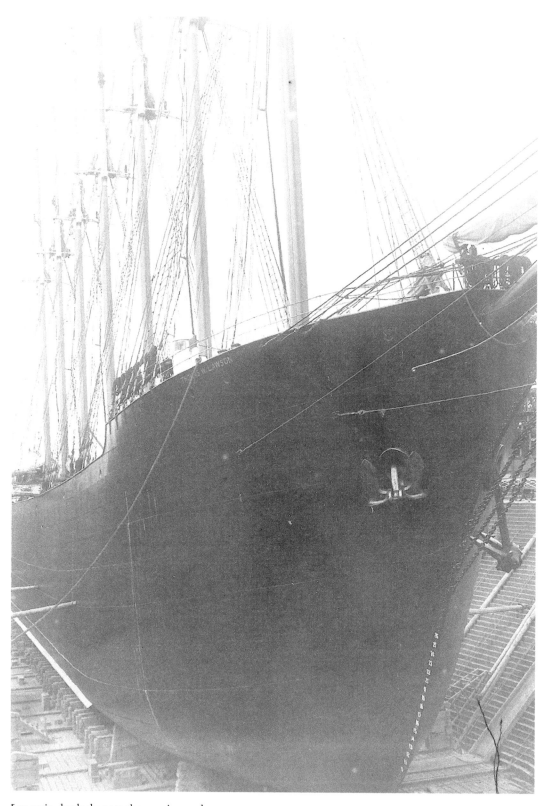

Lawson in drydock; note the massive anchors.

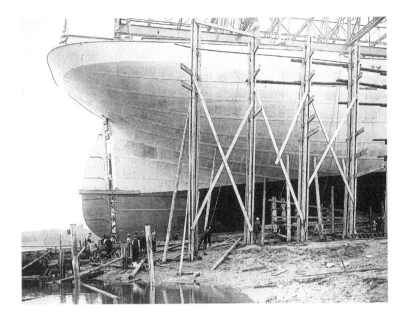

Launch day. Note huge
stern overhang and rudder.

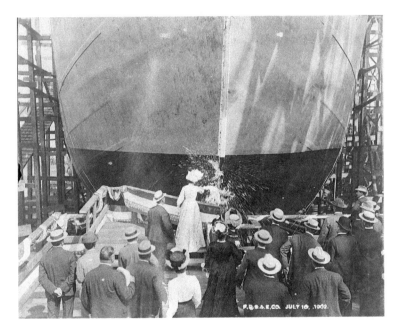

The *Lawson* was rigged
and launched July 10,
1902, only eight months
after the keel was laid.
Helen Watson, daughter
of the shipyard's founder,
christened the ship, with
twenty thousand spectators
on hand for the big day. It
was launched with the masts
stepped, an unusual move in
those days.

waterline, 175 feet. With its seven masts, everyone agreed that
the ship looked very much like a picket fence from a distance.

Naming the masts on the *Lawson* has always been a source
of controversy and fun. There was no precedent for naming
seven different masts. Ten six-masted schooners had already
been built, and their six masts had accepted names: fore,
main, mizzen, jigger, driver, spanker. But for the seven-masted

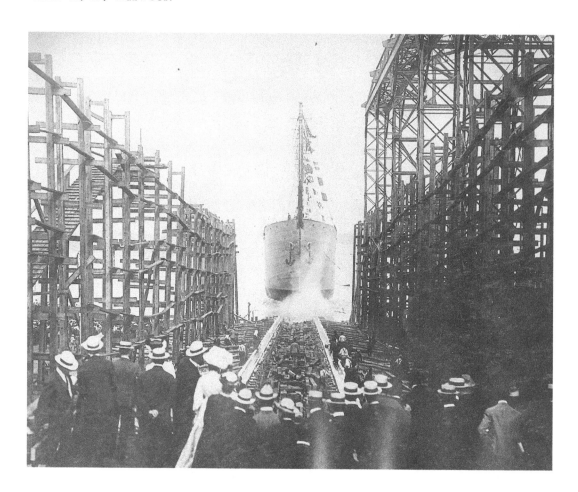

The ship's colors were given by Thomas Lawson, who did not attend the launching. Tugs stood by in the bay, ready to stop the ship from running aground if her massive momentum carried her to the far shore.

schooner, there was and still is a great deal of disagreement. The only area of agreement seems to be with the first three masts, named fore, main and mizzen. After that, opinions vary. Captain Arthur Crowley called the last four masts numbers 4, 5, 6 and spanker, claiming spankers were always the after sail.

Other names for those last four masts include after mizzen, jigger, driver and spanker; or middle, spanker, driver and pusher. Thomas Lawson himself is said to have referred to the seven masts by the names of the seven days of the week, Sunday through Saturday. Knowing the practicality of most seamen, though, I imagine they usually just called them numbers one through seven. The only possible problem with this numbered method might have been the chance for confusion between the "fore" mast (the first one) and the number "four" mast.

Spread over these masts were twenty-five sails—nearly one acre—of heavy canvas made by E.L. Rowe and Son of Gloucester.

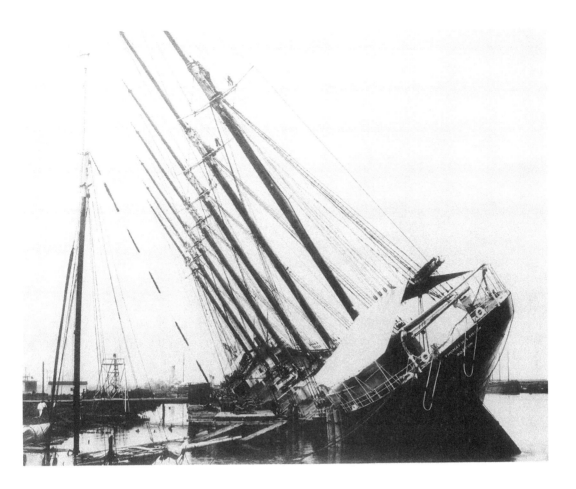

The *Lawson*'s size and large sail area made her unwieldy; she nearly capsized in Sabine, Texas.

Operating the *T.W. Lawson*

The *Lawson* was rigged and launched July 10, 1902, only eight months after the keel was laid. Helen Watson, daughter of the shipyard's founder, christened the ship, with twenty thousand spectators on hand for the big day. The ship had cost about a quarter of a million dollars to build, or $47 for each of its 5,218 registered tons—seemingly very cost-effective. At the turn of the century, average construction costs per ton for schooners, wooden and steel, ranged from $35 to $60. Since the Crowleys' Coastwise Shipping Company reported financial results as an aggregate of all their ships, no specific financial information exists for the *T.W. Lawson*. With normal freight activity, however, the seven-masted schooner would certainly have paid for itself as fast as any ship of any construction. Estimates of financial return range from 22 to 66 percent a year. And as a steel ship, the *Lawson* would have gotten the maximum twenty-year life

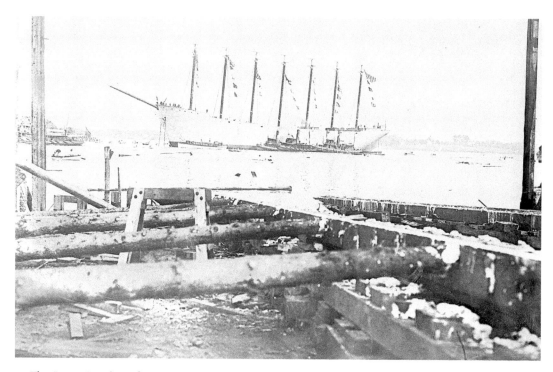

The *Lawson* in colors after
the launch.

expectancy rating from insurers, which of course assumes that some luck would be with the ship.

By the time the *Lawson* was launched, because the favorable changes to international manning hoped for by Thomas Lawson and the Crowley brothers had not materialized, the schooner was put into service hauling coal up and down the United States coast. Under the command of Arthur Crowley, the *Lawson* pulled into the few harbors in Virginia and Texas that could take a thirty-two-foot draft.

Loaded, in heavy winds, with plenty of water, the *T.W. Lawson* was an excellent sailing vessel, even making it once from Cape Henry to Cape Cod in fifty-two hours, averaging a remarkable ten knots an hour. In anything less it was a noisy crank. In light winds, the steel mast hoops rattled relentlessly and the ship was frequently towed to its destination by the ocean tug *John Paul Jones*. During early trials, when the designer Crowninshield asked how long it would take to tack, the reply came back: "Well! You go below and eat your dinner and when you come on deck she may be off on the other tack." High freeboard, weight, fore and aft rigging—all contributed to the schooner's stubbornness.

To change the *Lawson*'s heading, Captain Crowley and his crew had to be very creative. When the wheel was put down

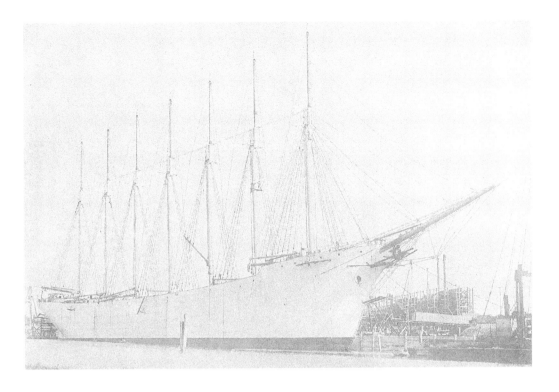

Dockside, being rigged.

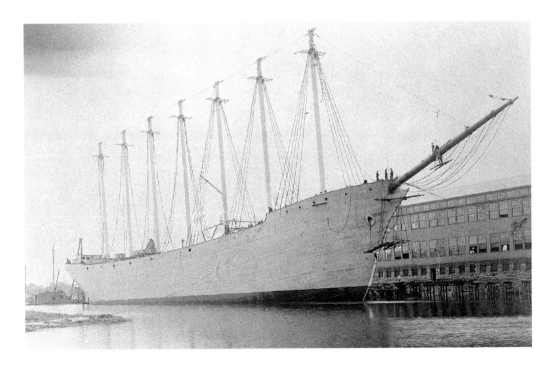

Dockside.

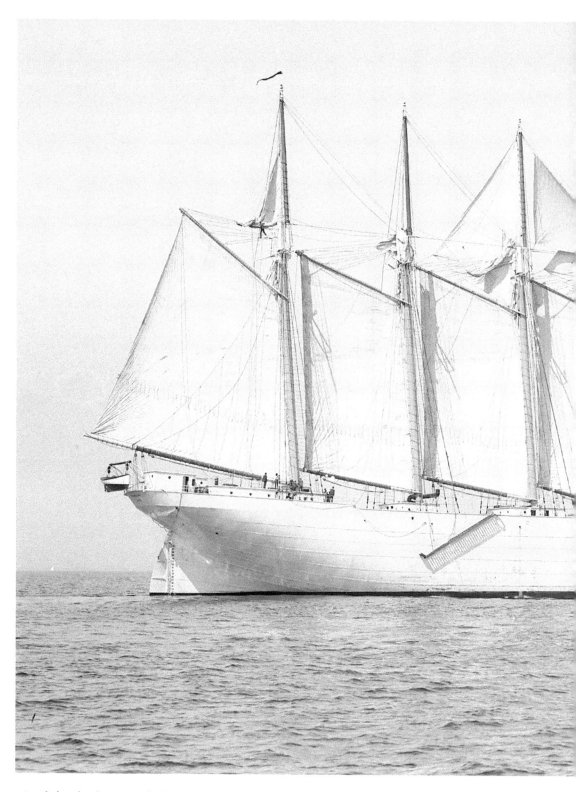

Loaded and in heavy winds, the *Lawson* was a fine sailing vessel, but in anything less, the schooner was a noisy crank. In light winds, its steel mast hoops rattled relentlessly and the ship frequently had to be towed to its destination.

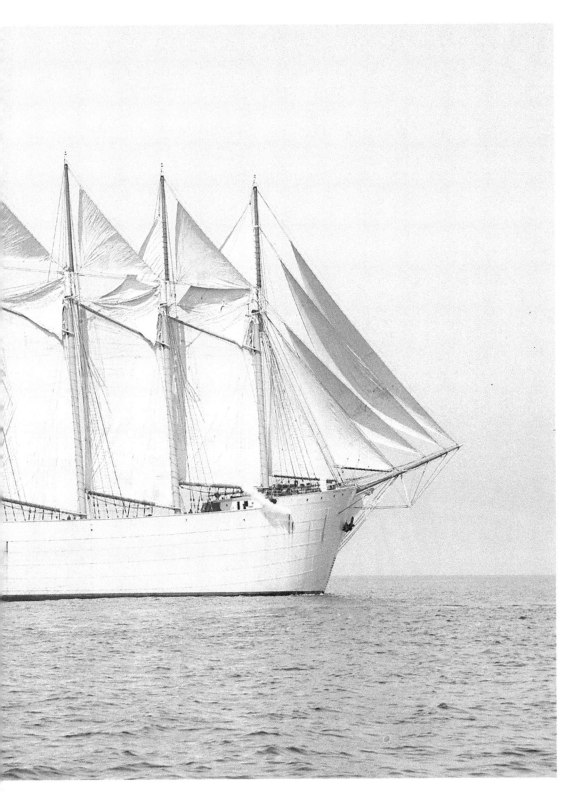

During early trials, designer Crowninshield asked how long it would take to tack. The reply was "Well! You go below and eat your dinner and when you come on deck she may be off on the other tack." High freeboard, weight, fore and after rig—all contributed to her stubbornness.

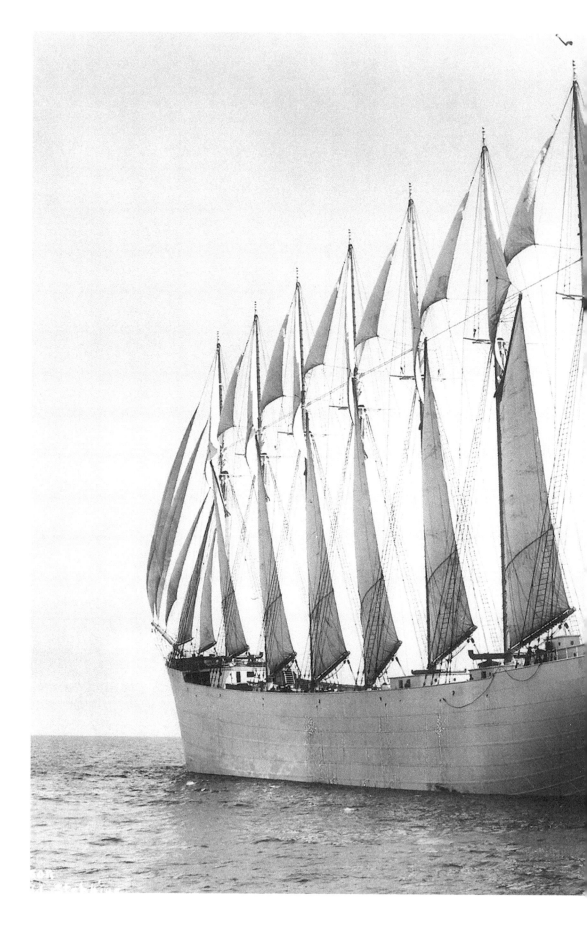

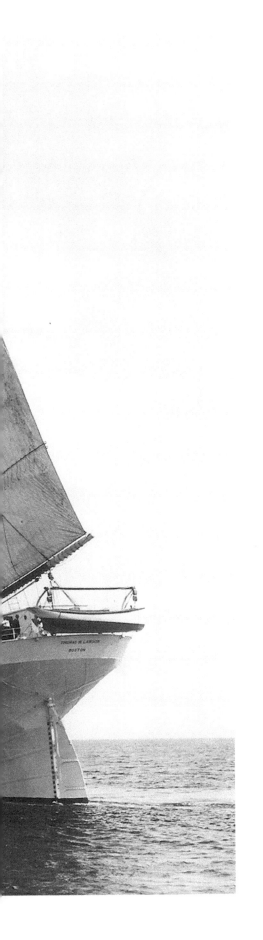

Unfortunately, by the time the *Lawson* was launched, the favorable changes in international manning laws that Thomas Lawson and the Crowley brothers had hoped for had not materialized. The schooner was put into service hauling coal up and down the East Coast of the United States. Under the command of Captain Arthur Crowley, the *Lawson* pulled in to the few harbors in Virginia and Texas that could take a thirty-two-foot draft.

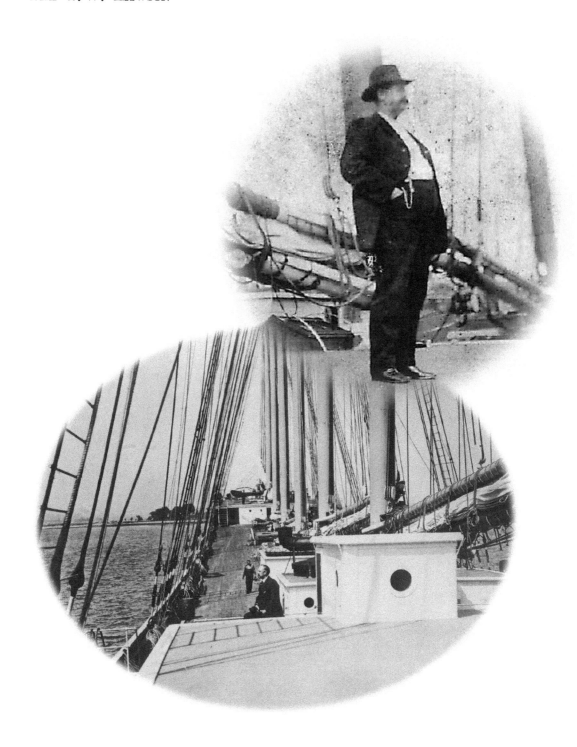

Top: Captain George Dow, from a well-known seafaring family in Hancock, Maine, on the deck of the *T.W. Lawson*. *Bottom:* Thomas Lawson on the deck of his namesake.

"hard-a-lee," head sheets were slacked up, and at the same time the after boom, acting as an "aerial rudder," was hauled to weather as the ship came in to the wind. When the *Lawson* was head to wind and almost stopped, the head sails were sheeted full aback and first the foreboom then the main boom were hauled to port, if heading for a starboard tack, and paid off almost wind abeam and gathered way. If that didn't work, other options included wearing around, which lost valuable distance to leeward, or dropping the anchor, alternately working the sails and "club-hauling her" around.

The *Lawson* sailed like this for five years, shadowed by a tug, and paying off nicely for its owners. Arthur Crowley commanded her for the most part, though skippers Murdock Mclean, Elliot Gardner and Emmons Babbit also had their turn in the barrel. She frequently ran aground, but never sprung a leak, which is another testimony to the ship's strong steel construction.

The unfortunate truth is that the *T.W. Lawson* was not well designed for either the coastal or transoceanic trade. Although the fore and aft rigs made it theoretically possible to adjust for the variable coastal winds, the ship could not easily come about, and its deep draft prevented compliance with the coastal maxim to "stay within sight of land." And as for the transpacific or transatlantic trade, the *Lawson's* relatively short masts and absence of square rigging caused it to lose wind and steerage in the dangerous trough of the great ocean swells. The sails and rigging would then pay a severe price as the ship violently caught wind again coming out of the trough.

And as modern a ship as the *T.W. Lawson* was at that time, it still failed to take full advantage of emerging steam and engine technology. A small bow thruster to help the ship come about or a small screw aft to provide some propulsion when in trouble would have been of great benefit without commandeering too much precious moneymaking cargo space. At a time when small steam engines were raising sails and hoisting freight, one could certainly have been developed for this purpose on the *Lawson*. The *T.W. Lawson* would end up paying dearly for its hybrid hull and sail design and its sole reliance on wind power.

In 1906, when coal rates dropped below sixty cents, the *T.W. Lawson* became less profitable. The ship was leased to

> To change the Lawson's heading, Captain Crowley and his crew had to be very creative.

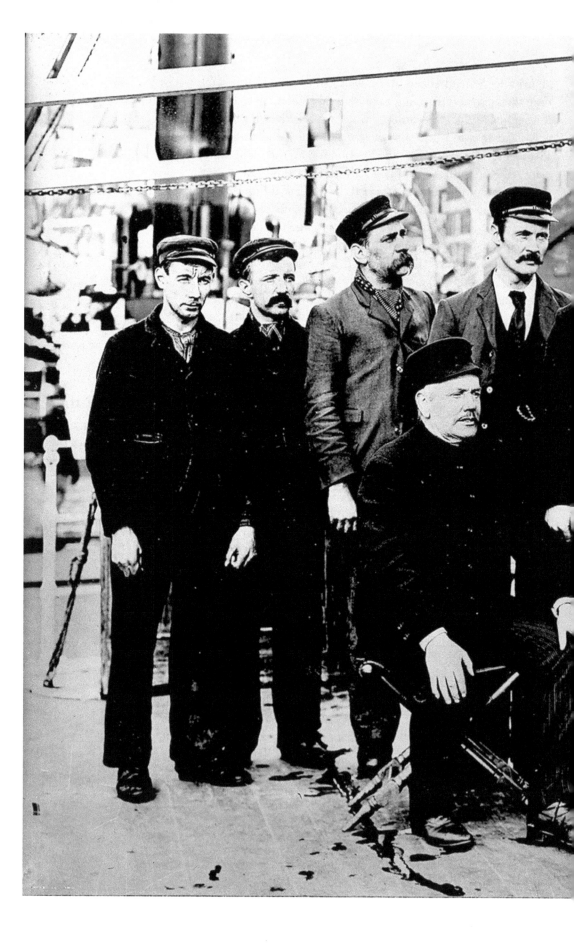

Crew of the *Lawson*
surrounding
Captain Arthur
Crowley, seated.

the Sun Oil Company and refitted to handle bulk liquids at Newport News, Virginia. Since shipping liquid fuel in bulk was in its infancy, the engineers and crew of the *T.W. Lawson* were again cutting new ground and designing on the fly. The holds were divided into seven pairs of tanks, first with wood and then, after the wood failed to seal properly, with steel. The topmasts were removed for venting, reducing the maximum number of sails to ten from twenty-five, and the schooner was painted black. This new configuration proved tricky; the ship almost capsized twice due to unbalanced loading. By 1907, Captain Crowley had quit as the *Lawson*'s skipper; some say because he was tired, and others because of a dispute over the next commercial venture for the *T.W. Lawson*—to sail oil cargo across the Atlantic to London.

> To capitalize on the strong demand for liquid fuels in London, the schooner was loaded with two and a quarter million gallons of light oil at Marcus Hook refinery in Pennsylvania, on November 19, 1907.

To capitalize on the strong demand for liquid fuels in London, the schooner was loaded with two and a quarter million gallons of light oil at Marcus Hook refinery in Pennsylvania, on November 19, 1907, and readied to make the long journey to England. Ironically, 1907 was also the first year in which tonnage carried by steamships exceeded tonnage by sail.

Across the Atlantic

It was never easy to get crew for the *Lawson*. Whether because of the poor pay or the schooner's "cursed" reputation, it rarely sailed with the same crew twice. Of the eighteen men who departed in November 1907, most were foreigners and probably didn't speak English well. Seven of the crew hailed from the United States, from New York, Maine and Massachusetts. The foreign crewmembers came mostly from Scandinavia and Germany.

The sailors before the mast were inexperienced and unreliable. Most of the men were in their early twenties. Two days before departure, six crewmembers had quit over a pay dispute and Captain George Dow, the ship's new captain, had to scour the waterfront and find replacements. Under that kind of pressure, what he found were probably more like warm bodies than able-bodied seamen. Along the waterfront, the *Lawson* was well known as an unlucky boat. Sailors wondered why Captain Crowley wouldn't sail it anymore. They knew the schooner ran aground a lot and had trouble coming about. Even the fact that Thomas W. Lawson's name and that of the Sun Oil Company, which was leasing the *Lawson*, each contained thirteen letters

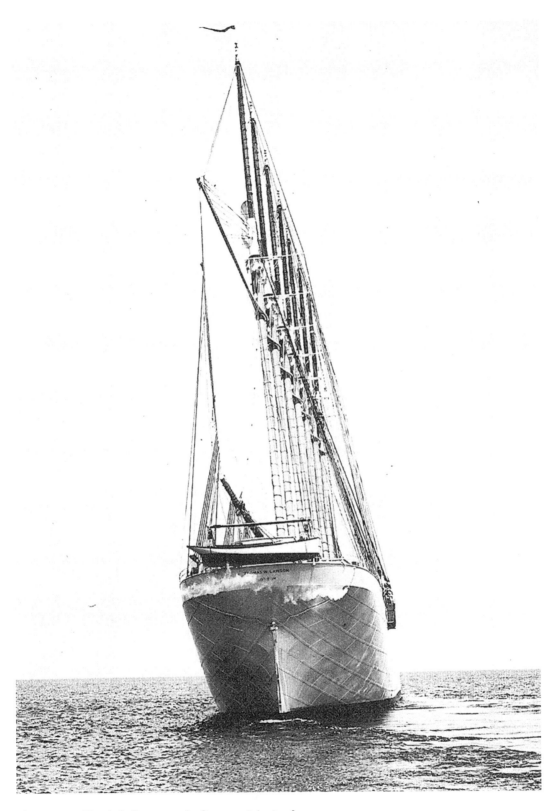

The *Lawson* sailing in ballast; note the fine captain's gig aft.

would not have escaped the sailors. So it wasn't easy to find first-rate sailors.

Leading this unimpressive crew, however, were a very experienced captain, first mate and engineer. Captain George Dow, part of a well-known seafaring family from Hancock, Maine, had been newly hired for the transatlantic trip. Dow, age fifty-nine, had lengthy experience commanding large sailing ships for the John S. Emery Company of Boston. He had served on the schooners *Everglade* and *Albert L. Butler*, and the barks *Colorado* and *Auburndale*. He commanded the latter ship for twelve years and was considered by many seafarers to be more comfortable on square-riggers, though he certainly was qualified on schooners.

His first mate, Bent P. Libby, age thirty-four, had sailed before with Dow but had since retired from sea life and was working in Boston and raising a family. Captain Dow talked Libby into sailing on the *Lawson* "one last time," as payback for an earlier promotion he had given him. The engineer was Edward Rowe, age thirty-five—the most experienced *Lawson* sailor, joining shortly after the ship's launch in 1902. It was engineer Rowe who had come to the rescue when the *Lawson* nearly capsized from improper loading in Sabine, Texas, and again in Newport News, Virginia, rebalancing the load and righting ship.

On the morning of November 19, 1907, the *Lawson* departed with this crew: Captain George W. Dow of Hancock, Maine, and Melrose, Massachusetts; First Mate Bent P. Libby of Marlborough, Massachusetts; Second Mate O. Crocker of New York, New York; steward George Miller of Boston, Massachusetts; cabin boy Mark Stenson of Brooklyn, New York; engineer Edward L. Rowe of Wiscasset, Maine; firemen John Krase and Z. Olanssen of Sweden; and seamen Gustev England and John Lunde of Norway, Ole Olsen and A. Petersen of Denmark, Gustav Bohnke of Germany, Anton Andrade of Austria, L. Garrison of Venezuela, N. Peterson of Russia, George W. Allen of Battersea, England, and P.A. Burke of Tonawonde, New York.

As if to foreshadow the fate that awaited the ragged crew, the *Lawson* promptly ran aground after casting off and was pulled off the sand by its trusty shadow, the tugboat *Paraquay*. The *Lawson* then sailed down the Delaware River to the Atlantic Ocean and turned northeastward, taking a great circle route toward London. In fair weather, at normal cruising speeds of eight to nine knots, the three-thousand-mile trip

> Leading this unimpressive crew, however, were a very experienced captain, first mate and engineer.

should have taken about fifteen days. The weather along the eastern seaboard was fair when the *Lawson* set off. After three days it was sighted off the Grand Banks by the passenger liner *Barnsmore* out of Antwerp, which reported later that the *Lawson* had been in fine shape at the time.

The *Lawson* wasn't sighted again for twenty-two days. The only reports we have of the transit come from Edward Rowe, the engineer. After sighting the *Barnsmore*, Rowe reported the *Lawson* hit a series of three gales with gusts over ninety miles per hour. The three gales ripped all but six of the ships' sails and splintered all three of the life rafts. In between the gales the *Lawson* was becalmed.

We can imagine the mighty *Lawson*, all 404 feet and 10,860 tons of it, surfing down the blustery waves at twenty knots, only to lose its way in the trough as the waves blocked the wind, rattling the big steel mast hoops. The ship would come to life with fury as the mainsails peaked above the trough, punched full of air and then listed violently, ripping the rigging, the lifeboats, the poop decks, machinery and men.

And this must have been repeated over and over again, until the *Lawson* moved only under bare poles—and at times made twelve knots doing so. We don't know all the details of what happened on that transatlantic crossing, but from what we do know, it's clear that the crew must have been thoroughly exhausted and demoralized as they finally neared England and their destination.

> The *Lawson* wasn't sighted again for twenty-two days.

On the early afternoon of Friday, December 13, 1907, the crew of the *Lawson* saw what appeared to be a ship in the distance off its starboard bow, to the southeast. As the snow and fog cleared, however, Captain Dow began to recognize the structure not as a ship's mast, but as the notorious Bishop's Rock Lighthouse off the Isles of Scilly, off the far southwestern tip of England. And he was on the wrong side. Normal transits to England keep well west and south of Bishop's Rock Lighthouse, usually the first navigational aid seen after crossing the Atlantic, and then turn up the channel between England and France toward London.

Captain Dow, understanding his precarious position, dropped the two five-ton anchors, 150 fathoms on the port side and 90 on the starboard side (staggering rode like that was designed to ease straining and dragging). With the anchors secured, in spite of the position, Dow thought that they were safe for the moment and the exhausted crew could finally rest.

In Bishop's Rock Lighthouse, however, the keepers sent up a flare at once when they sighted the *Lawson*. Seeing the flare and the seven pickets among the Western Rocks, the people on the Isles of Scilly instinctively knew that the ship's crew was in no position to relax, even if the crew itself had no real idea what kind of danger it was in.

With the anchors secured, in spite of the position, Dow thought that they were safe for the moment and the exhausted crew could finally rest.

Part Two

Beautiful, dark, and solitary
The first of England that spoke to me
—Laurence Binyon

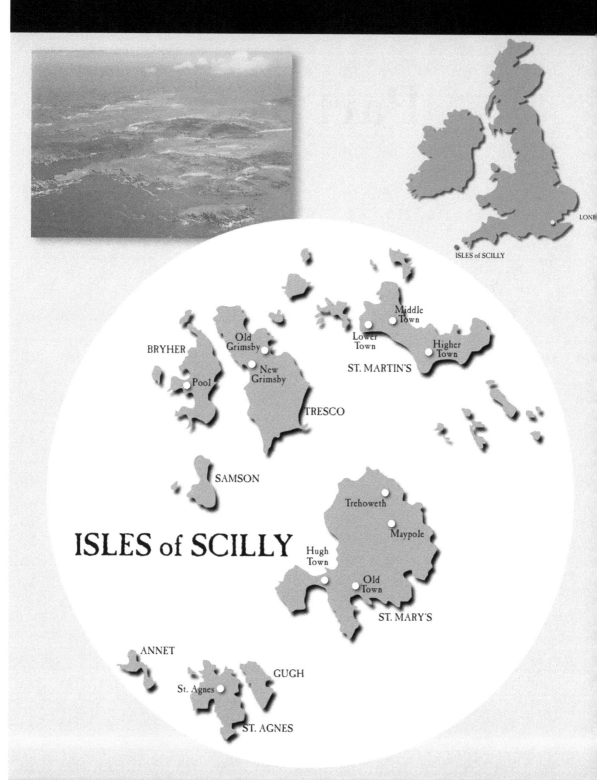

Five main islands on the Isles of Scilly, twenty-eight miles southwest of Cornwall.

THE OTHER SIDE OF THE ATLANTIC

The Isles of Scilly
The "Fortunate Islands"

To understand what happened next, some understanding of the Isles of Scilly is necessary. The Isles of Scilly are a collection of about sixty islands, located twenty-eight miles southwest of Land's End (Cornwall, England). There are five inhabited islands in the Isles of Scilly, called St. Agnes, Tresco, St. Mary's, Bryher and St. Martin's. St. Mary's is the largest, less than three miles across at its widest point and ten miles around its coastline. The rest of the islands aren't really islands at all, but granite rock formations rising from the ocean like broken city buildings. Their odd shapes have gotten them names like "Old Woman's House," with its two chimneys, and "Hellweathers," an appropriately named rock vortex littered with wrecks.

To imagine the formation of these islands, think of a mountain of crushed granite off the coast of Land's End, and then picture strong winds blowing this pile of jagged rocks to the southwest. The smaller pieces would sail out to the edge, and as you moved southwestward, the islands would get smaller, rougher and more numerous. When the dust settled, the larger inhabited islands of St. Martin's, Tresco, St. Mary's and Bryher would still be sitting closest to the mainland, with the smaller islands of St. Agnes and Annet a little ways off; fanning farthest out, finally, would be the treacherous uninhabited Western Rocks. From

It has been said that there is no collection of rocks in the world more treacherous than the Western Rocks off the Isles of Scilly.

View of St. Agnes from the Star Castle on St. Mary's. Note the lighthouse on St. Agnes. The *T.W. Lawson* would have been anchored and then wrecked in the distance on the right.

north to south the isles span eleven miles, and five miles east to west.

Shipwrecks

It has been said that there is no collection of rocks in the world more treacherous than the Western Rocks off the Isles of Scilly. These rocks lie in waiting close to the main shipping routes and are arranged like a labyrinth to snare imprudent or unfortunate ships. Many of the rocks lie just beneath the surface. Others are covered during heavy seas. With the North Atlantic current deviously pushing ships to the north, many masters are caught off guard. Adding to this deception are strong seas that sweep in from the wide fetch of the Atlantic to the west, augmented by strong tidal currents. When flooding, these tidal currents can reach three knots to the northeast toward Annet and the surrounding islands.

Over the centuries of imperfect navigation and reliance on sail, it is not surprising that the Isles of Scilly and the infamous Western Rocks, with their low silhouette, claimed more than

their share of ships and of the bounty that came with them. In 1860, Sir Walter Besant claimed that "every rock in Scilly has a shipwreck." According to Richard Larn, who has written extensively about wrecks around Cornwall and the Isles of Scilly, more than 200 wrecks have been recorded from the seventeenth century to the present; there are a total of over 650 wrecks in the waters around Scilly. Coming east from America, the islands are the first landfall after a voyage of over three thousand miles, and from the south and east, the isles are equally dangerous. One can imagine the horror of sighting land after a long and stormy voyage or a battle, only to find yourself inside these rocks.

The worst Scilly shipwreck disaster in memory occurred in 1707, when four ships from Sir Cloudesley Shovel's fleet returning from Gibraltar after a victorious battle against the French struck the Western Rocks. The flagship *Association* and the large ships *Eagle*, *Firebrand* and *Romney* were lost, along with two thousand men. The only survivor saved himself by floating on a piece of timber to Hellweathers Rock, where he remained for days until he could be taken off.

The sinking of Shovel's fleet highlighted the need to improve navigation, especially the determination of longitude. The loss

> One can imagine the horror of sighting land after a long and stormy voyage or a battle, only to find yourself inside these rocks.

St. Mary's and
surrounding
isles from
the air.

of those two thousand sailors precipitated the Longitude Act of 1714, in which Parliament promised a prize of twenty thousand pounds for a solution to the problem of longitude.

Trinity House

Wrecks like Shovel's unfortunately were common around the Isles of Scilly and had also prompted other moves to reduce the dangers to shipping. The Wardens of the Guild and Brotherhood of the most Glorious and Undividable Trinity in the County of Kent—"Trinity House"—was incorporated in 1514 by Henry VIII to ensure safe regulation of shipping on the River Thames. Without regulation, anyone claiming to be a pilot could assume those duties, putting life and trade at risk. The corporation of Trinity House had three main functions. It was primarily responsible for providing lighthouses, light vessels, buoys and beacons in England, Wales, the Channel Islands and Gibraltar. Its second key function was charitable relief of mariners and their dependants in distress; and the third, and perhaps most important, role of Trinity House was the regulation and licensing of pilots for London and forty other districts, such as the Isles of Scilly, known as "outposts." Although it licensed pilots, Trinity House did not employ them; pilots were self-employed. In the areas controlled by Trinity House, licensed pilots and local pilots were paid a controlled rate for ships they handled.

> Wrecks like Shovel's unfortunately were common around the Isles of Scilly and had also prompted other moves to reduce the dangers to shipping.

In 1680, King Charles II granted Trinity House power and license "to erect and maintain one or more lighthouses upon any of the islands and to receive such allowance for maintenance of the same as should be thought fit and reasonable according to law." Since destruction between St. Agnes and the Western Rocks was especially brutal and frequent, a lighthouse was built on St. Agnes soon after King Charles's grant. The light was a coal fired in a brazier inside a lantern over a brick lantern. This setup was not satisfactorily improved until 1807, with the addition of thirty lamps burning spermaceti.

Bishop's Rock Lighthouse

When it became obvious that a warning light marking the extreme edge of the Western Rocks was also absolutely essential, Bishop's Rock was chosen. Bishop's Rock, named after Miles

Bishop, a survivor of an eighteenth-century Spanish wreck, was a treacherous reef with a notorious past. For centuries, the Rock had been used to incarcerate felons. In 1284, it was written "when anyone is attainted of a felony he ought to be taken to a certain rock in the sea and with two barley loaves and one pitcher of water upon the same rock they leave the same felon, until by the flowing of the sea he is swallowed up."

The lighthouse was first constructed as an open structure of cast iron 120 feet high, supported by nine iron piles driven into the rock, but was washed away by a heavy sea in 1850 before it could be put into service. It was rebuilt of granite in the mid-1850s then strengthened in 1887 with the addition of an outer casing and two extra stories, bringing it to its present height of 167 feet.

A slender pinnacle standing on rock almost submerged at high water, Bishop's Rock Lighthouse is one of the two best-known and certainly tallest lighthouses in the British Isles. Beautiful, dark and solitary, it is the first sign of England many sailors would see after crossing the Atlantic. The lighthouse has a white light flashing every fifteen seconds and an explosive fog signal that gives one report similar to a gun blast every five minutes. It is eerily similar to the granite lighthouse Thomas Lawson would have seen out his window in Scituate on the other side of the Atlantic. Called "Lovers' Light" for its "1-4-3" light flashes (meaning *I love you*), Minot's light also was originally made of nine-pile iron construction, destroyed and rebuilt of granite 114 feet high in the 1850s and stands to this day.

> Bishop's Rock Lighthouse is one of the two best-known and certainly tallest lighthouses in the British Isles.

Scillonians and Their Reputation

Scillonians have distinguished themselves as lifesavers, risking and often losing their lives attempting to save crews of shipwrecked vessels. Those sailors who lived often did so because of the gallantry displayed by the islanders.

And yet the same wrecks that threw sailors into the sea, to be saved at times by the people of Scilly, also produced bounty for the Scillonians. Their land had very few natural resources. Islanders grew wheat, barley, wild oats and potatoes. Cattle and horses were small and generally poor, eating mostly seaweed and the furze they scrounged in the hills. Foot-long "whistling fish" were occasionally serenaded to the shore and caught

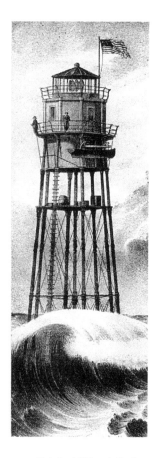

Original Minot's Ledge
Lighthouse, Scituate,
Massachusetts. Both
Bishop's and Minot's
Lighthouses were originally
built of nine-ironpile
construction and destroyed
by storms shortly thereafter.

by whistling fishermen. Cargo from wrecked ships, then, was essential to the very survival of the people, and because they lived off the wrecks of ships, ships' crews often regarded them with suspicion.

Life on the Isles of Scilly was feast or famine. In "bad" years, when wrecks were sparse, the people lived poorly off the land and shoreline. When wrecks were plentiful, they feasted. In 1796, John Troutbeck wrote that Scillonians "are by their situation the sons and daughters of God's providence and accordingly are otherwise clothed and supplied out of the wrecks sent in by the sea, the spoil out of their rich neighbors." Wrecks threw off everything from food, timber, paint and flour to wire, leather, iron and carpets. No Scillonian could afford to miss out. When a family was living near starvation, struggling to keep children clothed and fed, who could blame them for wishing for a good wreck to come ashore?

When a local Scilly pilot went out to board a ship in peril and guide it to safety, there was always the thought (the hope?) that the ship might have been, or might soon be, abandoned by its crew. When that happened, the local pilot would gain control of the vessel and reap rewards from the ship's owner. Merely being the first to bring the news of a wreck to the receiver at the Customs House on St. Mary's brought a reward of five shillings. Larger sums, to be shared by those responsible, would be awarded by the owner of a derelict or damaged ship towed in and saved. Since islanders came to regard the proceeds of shipwrecks as part of their natural harvest, it is understandable that they may have objected to the erection of lighthouses "because it would rob them of God's Grace." Scillonians have been known to pray, "O Lord, not that wrecks should happen, but that if any wrecks should happen, thou wilt guide them into the Scilly Isles for the benefit of the poor inhabitants." Another prayer goes like this: "Good night father, good night mother, Good night friends and foes, God send a ship ashore before morning." Some young women would even pray, "Please God send us a good shipwreck so we can get married." One clergyman in St. Agnes, on being informed of a wreck while delivering his sermon, announced it from the pulpit, and was last out of the church. On the next occasion of a wreck he said nothing, but walked to the church door and from there made his announcement, adding, "This time we all start fair!"

The principle that guided islanders in their quest for valuable cargo was the "Right of Wreck." This right dates back to the Roman conquest where it is enshrined in Rhodian

Law and refers to the legal beneficiary of shipwrecks in a particular area. One technicality of the right was that if a man or even a dog escaped alive from a ship it was not considered a wreck. This led many to believe that Scillonians would commit murder to gain rights to a wreck. In 1724 it was written, "The sands covered in people, they are charged with strange bloody and cruel dealing, even sometimes with one another, but especially with poor distressed seamen who seek for help for their lives and find the rocks themselves not more cruel and merciless than the people who range about them for their prey."

The most notorious story of this nature occurred in 1707 with the wreck of Admiral Sir Cloudesley Shovel. Although only one sailor officially survived the wreck, it was rumored that Sir Cloudesley Shovel himself had also survived. The story goes that no sooner had the fifty-seven-year-old Shovel washed ashore and collapsed on the dry sand, no doubt reflecting on the biggest navigation mistake of his career, than a local woman combing the beach for cargo found his body and noticed the fine emerald ring on his finger. Thirty years later, on her deathbed, this woman supposedly confessed to her clergyman, producing the ring as proof of her guilt and contrition, that she had murdered the admiral and cut off his finger to obtain the ring.

Finally, however, there is little evidence that Scillonians ever willfully wrecked ships for their own benefit. These accusations are not confined to the Scillonians but have been made for centuries against islanders from Nantucket to Bimini and Fiji. Rumors of devious tricks—such as cows left to wander on the coast with lights attached to their tails to confuse ships—have never been substantiated. Admiral Shovel most likely met his end the same way as his two thousand shipmates: in the sea, the unfortunate victim of bad navigation, not a sinister woman. In fact, another story reported that a soldier found his body washed ashore, stole his ring and returned it to the family years later.

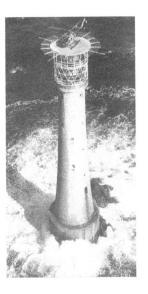

Bishop's Light, eerily similar to Minot's Light off of Thomas Lawson's Dreamwold estate.

St. Agnes

With a small population of about one hundred people at the turn of the century, St. Agnes is the most southwestern of the five inhabited islands of the Isles of Scilly. Overlooking the Western Rocks, St. Agnes, its tiny appendage Gugh Island and its smaller

View of Annet Island from the St. Agnes Lighthouse. The *T.W. Lawson* anchored in the distance beyond Annet, dragged anchor throughout the night of Friday, December 13, 1907, and wrecked near Shag Rock, several hundred yards off the back side of Annet.

uninhabited sister island Annet were the center of piloting and wrecks. The vigilant people of St. Agnes were usually the first to spot a ship in distress or in need of a pilot. Their pilot gigs and lifeboats responded quickly and were the first boats on the scene to transfer pilots, rescue crewmembers or gather valuable cargo produced from a wreck.

St. Agnes's shipwreck lore goes back to the twelfth century, when the island was named Hagness. According to legend, it was on St. Agnes that St. Warna landed on Scilly from Ireland on a small wicker boat called a coracle. He became the patron saint of shipwrecks for this tiny island. A cove on the southern side still bears his name, and contains an ancient wishing well into which islanders dropped pins and coins. St. Warna was certainly a productive patron, regularly drawing

ships into the treacherous rocks. At least a hundred and fifty wrecks have been identified around the Western Rocks and St. Agnes alone.

The island of St. Agnes is small, about two miles long north to south and a mile wide, covering 433 acres. Small single-lane paths, with beautiful hedges growing so high on both sides that they almost touch, give the place a mysterious, majestic feel. Because sailors returning from the tropics unknowingly deposited exotic seeds and wildlife not seen on the mainland, nature now provides St. Agnes and her sister islands with a feast of color all year round. You can walk knee deep in springy cushions of thrift, with their pink blooms and yellow daffodils, and be dazzled by the blood-red splashes of sorrel and the golden trefoil and gorse. Brilliant magenta and orange flowers

The most prominent feature of St. Agnes, however, is the old lighthouse built by a grant from Trinity House, in use for two and a half centuries, up until 1911.

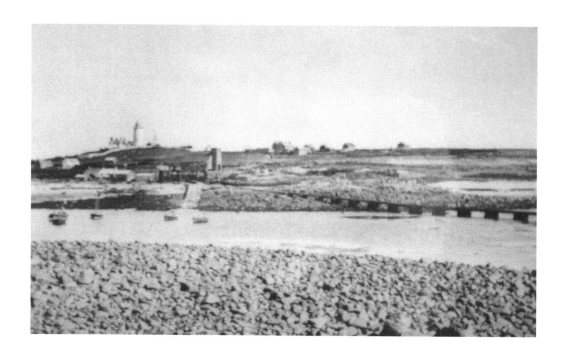

Boathouse at St. Agnes, circa 1905. Note the long and short slipways, and the church and lighthouse nearby.

surround the cottages. The Soleil D'Or, a rich yellow narcissus, the paperwhite and pretty daffodils such as the King Alfred and Fortune dot the islands. Rare birds—cormorants, gulls, auks, petrels and waders—stand watch over this wild and beautiful landscape most of the year.

To the east lies Gugh Island, a small mound of sand connected to St. Agnes by a spit at low tide. The curving sandbar between St. Agnes and Gugh, with its fine white sand, contrasts sharply with the magnificent granite buildings on the wilder western end of St. Agnes. To the south is Beady Pool, where beads from a seventeenth-century shipwreck lie buried in the sand. On the north side of St. Agnes, there is a small Anglican church built from a French wreck. The ship's bell still calls the faithful each Sunday. The words "in memory of those who put to sea from St. Agnes to save the lives of others" are inlaid into the stained glass behind the pulpit. The graves of the islanders, mostly named Hicks and a few named Legg, surround the old Anglican church.

The most prominent feature of St. Agnes, however, is the old lighthouse built by a grant from Trinity House, in use for two and a half centuries, up until 1911. When burning well, the light from this squat, circular white structure in the middle of St. Agnes could be seen from Land's End, but on many occasions, due to

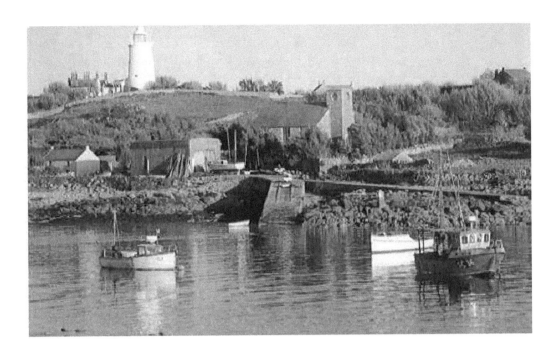

poor design and neglect, it couldn't even be seen from the big island of St. Mary's, only a mile away.

The Lifeboats

In 1907, as the *T.W. Lawson* was unknowingly making its way into the Western Rocks, St. Agnes had a lifeboat station that was only seventeen years old and a lifeboat, the *Charles Deere James*, that was only four years old. The lifeboat station on nearby St. Mary's Island had been built a year before the one on St. Agnes; the lifeboat on St. Mary's was the eight-year-old *Henry Dundas*. Lifeboat design had been evolving rapidly and had only recently moved beyond the standard self-righting lifeboat, which had many problems, including the fact that in order to be able to right itself after capsizing, it had to have a narrow beam, which made it less stable than non-self-righting boats and therefore more likely to capsize in the first place. Lifeboat stations and stone slipways for lifeboat launching were also recent improvements at that time. Both the *Charles Deere James* and the *Henry Dundas* were thirty-eight-foot-long non-self-righting lifeboats with wide beams. The *Henry Dundas* used twelve oars; the *Charles Deere James* ten, and each had a mast and sail fore as well as aft.

The St. Agnes boathouse sits next to the old stained-glass-windowed church off Periglis Bay, about a hundred yards beyond the old lighthouse.

Trinity House Pilots

One of the functions of Trinity House was to license pilots to guide boats around the waters of London and surrounding districts. To obtain a license, pilots had to fulfill a number of conditions: they had to have British nationality, have several years' experience as a ship's watch officer, hold a master mariner's certificate or naval certificate and be under thirty-five years old at the time of licensing. In addition, they had to undergo a Trinity House examination. In the outposts, such as Scilly, local pilots were appointed to examine new pilots and recommend them for license.

In small ports, Trinity House pilots were often fishermen and local seamen with special knowledge of the area. The title "Trinity House pilot" carried the reputation of expertise and credibility throughout England, and that reputation reached as far as the shores of America. (In the seventeenth century, pilots and their apprentices were often impressed into the Royal Navy because of their expertise and to cover the shortage of navy pilots.)

Trinity House, financed by fees on pilot earnings, pilot licensing and dues paid by vessels, worked diligently to gain control and bring order to piloting, frequently competing with other licensing groups in ports such as Bristol. Each pilot had to renew his license yearly, undergoing a test of general health, eyesight and knowledge of local waters. Into the twentieth century, however, operating alongside the licensed "Channel Pilots," there were always also unlicensed pilots, known as "dock pilots," as well as once-licensed Trinity House pilots who kept the title but failed to renew their license, courting high fines if caught.

Advances in ship design constantly threatened the pilots. Steam power and safety improvements meant new challenges in piloting the ships, while the rapid growth in ship size and improvements in speed meant that ships were less dependent on tides and wind, and therefore less dependent on the pilots. Ship owners also began using tugs and revolting against the need for pilots. Even legal forces were mounted against the pilots, as an 1812 act made pilots personally responsible for any damage done

> The title "Trinity House pilot" carried the reputation of expertise and credibility throughout England.

to other vessels or property while they were piloting a ship in distress, adding a worry that hung over the heads of pilots like the sword of Damocles.

Billy Cook (Hicks)

Born on St. Agnes and working the waters around Scilly, Billy Cook had been a Trinity House pilot for twenty-five years and was in his mid-fifties in 1907. I can imagine Billy Cook watching the wind drive frozen rain against the window of his small white cottage on St. Agnes, where he and his wife Elizabeth had brought up nine children. Facing west, over the beach where St. Warna landed in his basket, he would have had a clear view, from edge to edge of his large picture window, of Bishop's Light and the Western Rocks as large waves pounded over them, sending high plumes of white water to the sky. Billy Cook had seen weather this dirty many times and was surely glad to be inside. Pulling tobacco from his pouch and punching it into his salty pipe, he would have drifted back. In his half century on these isles and his decades as a pilot, he had seen enough to stand clear when the wild seas decided to take on the Western Rocks.

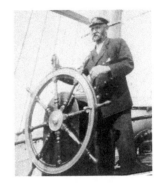

Billy Cook Hicks, born on the island of St. Agnes in 1857, got his Trinity House pilot's license in 1882.

Billy Cook probably thought of the huge west-northwest gale of 1888 that claimed the 701-ton *Bernardo*, throwing her captain onto Old Woman's House, off Annet Island, where he was lucky to be picked up. And the great blizzard of 1891 that pushed the 34-ton smack *Porth of Padstow* onto Minmanueth Rocks. Billy Cook worked the rescue that night on the ten-oared lifeboat *James and Caroline*, rescuing the master and his son, but the third crewmember was found frozen to death high above the tide line.

The strongest gale Billy Cook had ever heard about was in 1833, before he was born. Winds blew so hard from the west that it was impossible for a man to stand up, and he certainly couldn't look windward. The wind lifted a heavy rowing gig from Tresco up over two lengths, smashing her down on the rocks.

So that December 13, 1907, Billy Cook was glad to be inside. He had been watching the gale build since the beginning of the week. All the signs were there: the barometer was falling, the wind was backing slightly to the west-southwest, the sky was full of mare's tails and the moon—when he could see it through the banking of heavy cloud—had a white luminous ring. But it was

Freddie Cook Hicks, a hero of the rescue efforts.

the waves that were most unusual. At force eight or nine, about forty knots, he would have expected eight-foot waves, maybe, with crests breaking into spindrift. But the waves were much bigger, something a storm with winds around fifty knots would whip up. The crests of the waves were toppling over, with dense streaks of foam being carried by the wind toward St. Agnes. This wasn't going to be the windiest gale he'd ever seen, but those waves were certainly going to push around a few ships unlucky enough to be out there.

Only a fool, thought Billy Cook, would go out in a day like this. He went way back on this island and knew these waters and these rocks as well as anyone. One of those many St. Agnes Hicks descended from the original Hicks brothers who settled the island in the seventeenth century, Billy Cook was christened William Thomas Hicks but adopted the family nickname Cook so as not to be confused with all the others. No one is quite sure where the name Cook came from, but it was certainly useful in distinguishing among the relatives! He was also one of the most respected Trinity House pilots on the isles. He smiled as he thought of the old saying, "Being here and wishing you were out there is always better than being out there and wishing you were here." Nothing was truer, he thought. Billy Cook was no fool.

"Being here and wishing you were out there is always better than being out there and wishing you were here."

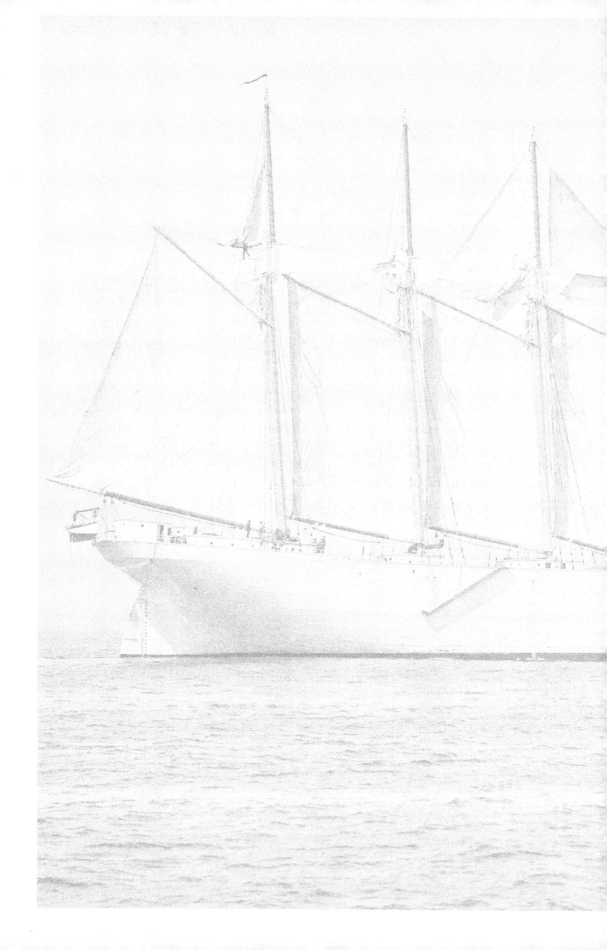

Part Three

The whole Atlantic
Amassed recoils
And in indolent thunder
Bursts and boils
—Laurence Binyon

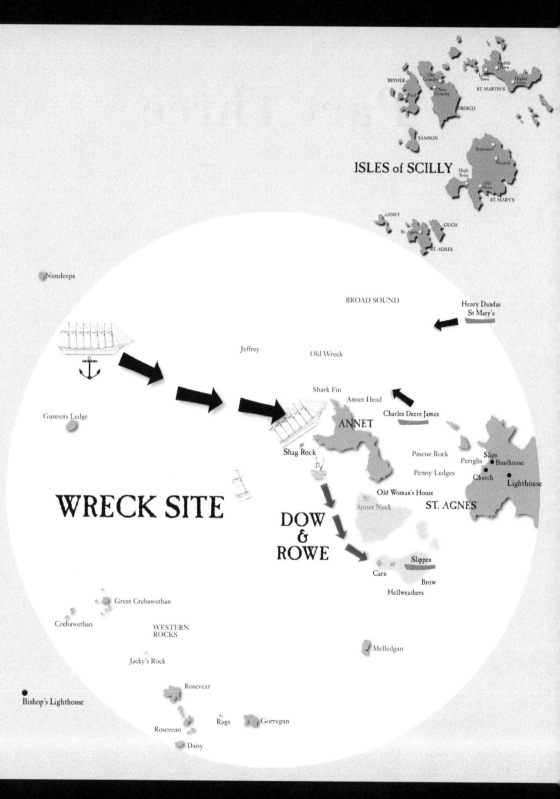

ISLES of SCILLY

BRYHER
Old Grimsby
New Grimsby
TRESCO
Lower Town
Middle Town
Higher Town
ST. MARTIN'S
SAMSON
Trenoweth
Maypole
High Town
Old Town
ST. MARY'S

ANNET
St. Agnes
GUGH
ST. AGNES

Nundeeps

BROAD SOUND

Henry Dundas
St Mary's

Jeffrey
Old Wreck

Shark Fin
Annet Head
Charles Deere James

Gunners Ledge

ANNET

Pascoe Rock
Slips
Periglis Boathouse
Penny Ledges
Church Lighthouse

Shag Rock

WRECK SITE

DOW
&
ROWE

Old Woman's House
Annet Neck
ST. AGNES

Slippen
Carn
Brow
Hellweathers

Great Crebawethan

Crebawethan
WESTERN
ROCKS

Melledgan

Jacky's Rock

Rosevear

Bishop's Lighthouse

Rosevean
Rags
Gorregan

Daisy

The *Lawson* dragged anchor throughout the night, wrecking on Shag Rock. Captain Dow and engineer Rowe drifted to Hellweather's Carn and were rescued.

The Wreck
December 13–14, 1907

Friday Afternoon

Billy Cook must have been woken from his warm winter reverie by his twenty-year-old son, Freddie.

"Wake up. George just saw a flare go up at Bishop's. There's a sailing ship anchored between Gunners Ledge and Nundeep. It looks like a picket fence," said Freddie.

Gunners Ledge and Nundeep are two notorious reefs located about two miles northeast of Bishop's and a mile or so west of Annet. The reefs are in an area called Broad Sound and mark the entrance to the Western Rocks, which are to the south of them. If the ship was between them, that meant it was already well inside of Bishop's Light and the labyrinth of rocks off St. Agnes.

"Freddie, what the hell are they doing there? Anchored? Are they sinking?" asked Billy, as he looked at his watch. It was two o'clock in the afternoon.

"She is riding about half up and looks all right, but in this dirty weather we can barely make her out. George wants to get the lifeboat out and see if she needs any help. Might need a pilot," said Freddie.

Billy looked outside and noticed the rain had stopped and the wind was west-southwest, about twenty-five knots. Not too bad. But those waves—they were still riding high, rolling pretty heavy from the west. This was no time to be riding out to Gunners.

"Who's up today?" asked Billy, wondering whose turn it was to pilot. As a close-knit group, with nearly all related in

> If the ship was between them, that meant it was already well inside of Bishop's Light and the labyrinth of rocks off St. Agnes.

some manner, the pilots on St. Agnes chose to rotate assignments instead of competing with each other, as pilots most other places would do.

"It is Abraham James's turn," replied Freddie. Billy and his son put on their oilskins and walked out the door and down the footpath, turned left and headed to the boathouse. They passed the old lighthouse on their right and slowed to say a prayer as they passed the stained-glass-windowed church on their left, as was their habit before going out to sea.

As they entered the boathouse, men were buzzing, adjusting their oilskins and talking about the large schooner anchored to the northwest. William George Mortimer, the lifeboat coxswain, was busy ordering the men and assembling the gear onto the small ten-oared lifeboat, the *Charles Deere James*.

Eleven men were getting ready in the boathouse when Billy and Freddie Cook entered. Besides coxswain Mortimer, there was second coxswain Abraham James Hicks, his son James Thomas Hicks, Obadiah Hicks, William Francis Hicks, William Treneary, Albert Hicks, Stephen Lewis Hicks, Fred Hicks, his brother Jack Hicks and Walter Long. With the arrival of Billy and his son Freddie, the lifeboat had its complement of ten oarsmen, two coxswains and a bowman, for a total of thirteen.

All were local volunteers from St. Agnes, except Walter Long, who was a coastguardsman from St. Mary's. Of the thirteen men, ten were named Hicks, which was typical of the dominance of this family on St. Agnes. The crew was composed of two father-son pairs and one set of brothers. The women of St. Agnes were always uncomfortable seeing their men load into a small lifeboat and brave the wild seas to save men they didn't even know. A barrel of cotton, an ornate figurehead or even a crewmember saved from a wreck would be small consolation if their husband or sons didn't return alive. But lifeboat work and piloting were the work of St. Agnes, and because of the island's small population—around one hundred in 1907, with two-thirds named Hicks—every male body, young or old, was needed.

By mid-afternoon on that Friday the thirteenth, all preparations for launch had been made. The tide was flooding, which produced one- to two-knot currents from the west toward Annet and Periglis Bay on St. Agnes. Coupled with the heavy rolling seas and west wind, this meant that launching the *Charles Deere James* was not an easy task. Two stone slipways had been added to the station in 1903, and now about half the crew pushed the boat toward

> But those waves—they were still riding high, rolling pretty heavy from the west. This was no time to be riding out to Gunners.

the water down the short slipway, which was used for high-water launching, while the other half sat in the boat ready to row. As they approached the sea, the crewmembers who had been pushing would begin jumping into the boat until it was underway, riding up and down the waves as they rolled in, occasionally breaking over the bow. The lifeboat was underway at 4:00 with the sun falling in the west.

Cold seawater, piercing snow, strong wind and fog met the crew of the *Charles Deere James* as they made their way through Periglis Bay and into the outer reaches of the Isles of Scilly. Since the wind was coming from the west, the crew had to row until they cleared Penny Ledges and Pascoe Rock, about two hundred yards west, where they would have enough room to raise the small sail and beat to windward toward the *T.W. Lawson*. Besides beating at them, the wind was freshening to about thirty knots per hour. The crew was quickly tired, cold and wet.

They rowed up and down over the large waves and against the tide for about ten minutes before they reached the end of Penny Ledges and prepared to raise the sail. Abraham James Hicks, second coxswain, spoke up.

"George, she's veering. Winds are freshening from the west-northwest now. Maybe we should take her north toward Annet Head and out," said Abraham.

Abraham, as second coxswain, could make that recommendation to the coxswain. Actually, any of the men could—as pilots and mariners they certainly all knew these waters. However, their recommendations could only go so far. The coxswain was in charge, no matter how close to him a crewmember was or how strong his opinion. One man had to be in charge and on that day, in that boat, it was George Mortimer who made the call.

"I feel it, she's veering; let's round Pascoe Rock, head up the sound and round Annet Head," said George Mortimer with very little deliberation. "But we'll have to keep rowing for a spell until we can turn a little farther north and get some help from this goddamn wind."

The sail remained furled on the boom as the boat turned to the northwest, up Smith Sound. Now on the lee of Annet Island the seas calmed a little and the *Charles Deere James* began making headway, passing Pascoe Rock on the starboard side and the length of Annet on the port side.

After about twenty minutes of rowing George Mortimer turned the boat to the northwest into the wind and raised the

Cold seawater, piercing snow, strong wind and fog met the crew of the *Charles Deere James* as they made their way through Periglis Bay and into the outer reaches of the Isles of Scilly.

sail, then fell off to the north. With a bang, the wind grabbed hold of the *Charles Deere James* and slapped her on beam-ends. With the rail buried, the lifeboat passed Annet Head on the northern end. No longer protected from the waves by Annet, the lifeboat faced the furious seas once again, beating into the weather; each wave crashed over the bow and filled the boat full of water. To keep it from sinking, safety valves were opened to drain the water down to seaworthy levels.

"Lash yourselves in, every one of you, because I am easing for nothing," boomed coxswain Mortimer.

The *Charles Deere James* then alternately turned to the north and then back to the southwest as it beat toward the *Lawson*, at anchor between two treacherous reefs two miles to the west-northwest of Annet Head. With a crew soaked and half frozen, the *Charles Deere James* passed Shark Fin Rock, the partially covered rock that looks like a fin frozen above the water, Old Wreck Rock and Jeffrey Rock, just below the surface. Each one of these sea mines only revealed itself as the waves receded, and only when there was light enough to see it. Otherwise, George Mortimer and his crew could avoid them all only because they had grown up around them and knew where they were instinctively, by feel. No captain from outside the Isles of Scilly could navigate around these rocks. They wouldn't stand a chance.

There was a sense of awe as the *Charles Deere James* approached the *T.W. Lawson* at around five in the afternoon of Friday, December 13. From a distance the seven masts looked like a pine forest or a picket fence. One of the crew said, "She's as long as from here to next week," and all nodded in agreement. Although it was fully loaded and down about halfway, the *Lawson*'s hull was still 20 feet above the seas. At the water line, it was 368 feet long, 404 feet overall, with an 85-foot bowsprit that made the ship look like a hornet. The steel construction and black hull only added to the ship's commanding character.

But as the crew of the *Charles Deere James* got closer to this massive sailing vessel, the most famous American schooner, they all could see it had gone through hell. Instead of a huge schooner that was simply in the wrong spot, the *T.W. Lawson* was a disabled hulk of steel at the mercy of the wild seas. This crew of experienced mariners noticed it all. They noticed that all the ship's lifeboats and gigs had been destroyed. All but a few of the sails were missing and those that remained were in tatters. Most of the structures on the forecastle and poop deck had been torn away. Even one of the holds was open on the weather deck.

There was a sense of awe as the Charles Deere James approached the T.W. Lawson at around five in the afternoon of Friday, December 13.

The crewmembers they could see on the deck of the *Lawson* were dragging. On the lifeboat, one of the crew thought aloud that the *Lawson* "looked like a half tide rock, never clear of the sweeping seas." Again, all nodded in agreement.

The *T.W. Lawson* had two anchors out that appeared to be holding against the strong tidal current, huge waves and heavy wind. The ship was heading northwest, anchor chains tight as banjo wire, riding up and down with the seas. Fortunately, the tidal currents seemed to be diminishing from their peak during the launching of the *Charles Deere James* an hour earlier. This was about the only good news the crew managed to find as they looked over the big schooner. The worst seemed to be over.

Captain Dow's Decision

As the lifeboat doused its sails and switched back to rowing, the chatter by the crew concerned all aspects of this great ship. What was it doing there? Would its anchors hold? What was it carrying? Where was it going? How many crewmembers? Any men from Cornwall? The lifeboat approached the *Lawson* from the port quarter and it was very rough. The sun was going down, which cast the large ship in a spooky shadow. As they got alongside, a large man peered over the side.

"Ahoy," said Captain Dow as he looked over the crew of the *Charles Deere James*.

"Captain, do you realize where you are?" asked coxswain George Mortimer.

"Yes, I am in the Scilly Isles," replied Captain Dow.

"Yes, but do you realize the dangerous position you are in?" asked Mortimer.

"Oh, I'm all right," Dow replied.

"Well, sir, you are not all right," said Mortimer.

"I've got both my anchors down and I've ridden out worse storms than this on the American side. I've had boats on either side of me drag their anchors and go aground but mine have held—I'm all right," said the captain.

"Beg your pardon, but you are not all right. You may have ridden out storms on the other side of the Atlantic Ocean, but not where you are now. I suggest you get underway or let my crew take you and your men to St. Agnes," suggested the coxswain.

But as the crew of the *Charles Deere James* got closer to this massive sailing vessel, the most famous American schooner, they all could see it had gone through hell.

Captain Dow was stunned by the request. *Certainly my anchors will hold*, he thought. *The tide has turned and I know the worst is over. All I need is a tug, some sail repair and a rested crew. The crew has been through a lot already. The* Lawson *doesn't sail well without a rested crew and all her sails. Can't get underway tonight.* And he thought of something more sinister: the wrecking reputation of the Isles of Scilly. He had no intention of giving up this ship, not to these men. *They care more about my cargo than about my men*, he thought.

"Have you a Trinity House pilot aboard?" asked Captain Dow.

"Yes," answered Mortimer

"Will he come aboard?" asked Dow.

With that request the crew members of the *Charles Deere James* huddled and began to discuss the request. Since it was Abraham James Hicks, the second coxswain, whose turn was up, all eyes turned to him.

"Abraham James, are you going aboard?" asked several of the crew. Abraham James looked around and saw the tired eyes of his mates. He felt the sea rise and fall beneath him and the lifeboat bang against the hull of the *Lawson*. He thought about his family on St. Agnes. It just didn't feel right.

"No, I am not," he replied.

"Why not?" they asked.

"We are here on a lifesaving service and I am not leaving this boat," he said.

"All right, if you're not going, I will," shouted Billy Cook, as he stood up, stowed his oar and prepared to go aboard the *T.W. Lawson*.

Freddie looked at his father with a combination of pride and suspicion. Why would he risk his life going aboard this vessel? What was there to gain? If the captain of this beast of a ship was too ignorant to save his men then let him pay the price, not his father. But Freddie Cook knew his father had made up his mind.

Billy Cook had made up his mind to risk going aboard the *T.W. Lawson* because there was more at stake than the prestige of rescuing many lives or collecting a pilot's fee. Every pilot— every mariner—on the Isles of Scilly knew that any ship in a perilous position like this could also yield vast wealth. Owners might award large sums to the pilot who saved a derelict or damaged ship. And there was the slight chance, under some circumstances, the entire ship and cargo could be claimed.

Billy Cook was keenly aware of the reward given to the pilot who saved the schooner *Strathisla* in 1880, after its crew

> Captain Dow was stunned by the request. *Certainly my anchors will hold*, he thought.

had abandoned it. He was honored throughout the isles. And for getting the vessel into St. Mary's, the pilot gig *Bernice* and the pilot cutters *Atlantic* and *Presto* were awarded almost fifty pounds each; for saving the crew, the gig *Agnes* received fifteen pounds.

Billy Cook was also aware of the *Ely Rise* and the *Castleford*. In 1878, about thirty-five pilots saved the provisions and furniture on board the SS *Ely Rise*, for which they claimed a hundred pounds. In 1887, the SS *Castleford* was lost on the Western Rocks, with twelve pounds going to St. Agnes for saving eighteen cattlemen, five hundred pounds to *Bryher* men for the rescue and care of sixty-six passengers and four stewardesses, plus five pounds for every head of cattle saved and one pound for every corpse buried.

"Put the ladder over the side," Billy Cook called up to the captain of the great ship. It was inky dark and the wind was howling. With the lifeboat constantly banging against the side of the *Lawson*, it was too dangerous to stay.

"You get a big warp and lay astern while I am talking to the captain. I will speak to you over the stern in a little while," said Billy Cook to the other crewmembers before he grabbed the ladder and struggled up it, whacking against the side of the hull with each wave. His waterlogged leather boots and heavy oilskins nearly doubled his own 170 pounds. When he finally reached the rail, two pairs of strong hands grabbed him and pulled him over and onto the deck of the *T.W. Lawson*. Billy Cook stood up, settled his boots and stared into the faces of men who had been at sea for too long. The *Charles Deere James* drifted back behind the *Lawson* and at the mercy of the seas.

"My name is Billy Cook, sir, Trinity House pilot, permission to come aboard," said Billy, asking the traditional question that really had only one answer.

"Permission granted, come aboard, welcome to the American sailing vessel, *T.W. Lawson*, from Boston," replied a robust man. "I am Captain George Dow. This is my first mate, Mr. Bent Libby. Please come this way."

Billy Cook walked aft along the port side, escorted by the two men, who were soon joined by a third. As they silently walked, Billy noticed the destruction around him. Ripped sails and lines were entangled on the deck. The davits that should have held lifeboats and gigs were twisted and empty. Several of the covers to the holds between the masts were

Every pilot— every mariner— on the Isles of Scilly knew that any ship in a perilous position like this could also yield vast wealth.

ripped off. In fact, any part of the vessel that rose above the deck—hatches, vents, the wheelhouse—was dented, crushed, mangled and useless. The long deck with its seven tall masts and assorted protrusions looked more like a highway pileup than a working vessel. *Jesus*, Billy thought, *this was a mess: what have these men been through?*

As the four men walked aft they noticed another lifeboat approaching on the starboard quarter. It was the *Henry Dundas*, the lifeboat from St. Mary's, that had been launched about a half hour after the *Charles Deere James*. Since St. Mary's was farther away it had just arrived, after a long and rough transit. The men rushed to the starboard rail and leaned over to talk with the approaching lifeboat.

"Who are they, Mr. Cook?" asked Captain Dow.

"They are from the lifeboat station on St. Mary's, the island in the distance over there. The boat is called *Henry Dundas*," replied Billy, as he pointed. The St. Mary's lifeboat was now within shouting distance.

"Ahoy, we are from the lifeboat station on St. Mary's. Do you require any assistance?" yelled the coxswain from the *Henry Dundas*, who now recognized his friend Billy Cook on the deck of the *Lawson*.

"No. No assistance is needed from your lifeboat. We are to stay the night at anchor and depart in the morning, winds permitting," said Captain Dow.

"Sir, we believe you are in a dangerous location. We recommend you let our lifeboats take your crew off to safety," said the coxswain of the *Henry Dundas*, who was having difficulty keeping his lifeboat steady. Captain Dow turned to Billy Cook.

"Sir, my crew and I will stay aboard and ride out the storm at anchor. They will hold. Would these isles of yours have a tug? If I need anything it would be a strong tug to stand by in case of trouble. I certainly will not abandon my vessel to any of your men," said Captain Dow. Billy Cook told Dow two tugs and the steamer *Lyonesse* were available on the mainland at Falmouth, forty miles away. It could take them up to eight hours to get here.

As they spoke, the *Henry Dundas* continued to have trouble maintaining its position along the starboard side of the *Lawson*. The lifeboat would ride the crest of the oncoming wave and veer to the right into the trough, then struggle to head back into the waves. After one particularly violent wave, the *Henry Dundas* gave up coming back into the waves and

Billy noticed the destruction around him. Ripped sails and lines were entangled on the deck. The davits that should have held lifeboats and gigs were twisted and empty.

started a complete circle around to the starboard quarter. As it approached the stern of the ship, it passed alongside the *Charles Deere James* that was trailing behind the ship, and the two crews exchanged nods.

Moving ahead of the *Charles Deere James* after a few minutes, the *Henry Dundas* suddenly caught a cross wave that pushed the boat under the stern overhang of the great ship, snapping the mizzenmast and covering the crew in lines and canvas. The *Henry Dundas* was repeatedly thrown against the bobbing stern of the *Lawson* for several harrowing minutes before the crew dislodged the boat and pushed free into the open water. Regaining composure, the crew of the *Henry Dundas* pulled up to where the captain, pilot and officers were watching.

"We have to return to St. Mary's. We have been damaged severely and as you can see our mizzen is useless. Would you like us to take back any crewmembers?" asked the coxswain.

"No. But radio the tugs in Falmouth and ask them to get underway immediately to stand by my vessel. We should like to be towed if there is any problem," said Captain Dow.

"Yessir. We will contact the *Lyonesse* by telegraph as soon as we get back. Billy, will you come with us?" asked the coxswain. Billy looked down and shook his head no.

"Do you have any messages for us?" asked the coxswain. Again Billy shook his head, no. With that, the *Henry Dundas* turned and rowed away. Billy watched as the boat surfed down the following seas, nearly swamped each time, as it disappeared into the dusk.

They walked to a companionway, down a ladder and into the captain's stateroom. It was now around seven o'clock, inky black with a few stars showing. The wind had lessened slightly but was still gusting to thirty knots from the west-northwest. The waves were still rolling heavily, unusually heavy, from the west, but the tide had turned and was ebbing.

They walked into the captain's stateroom. Billy looked around at the comfortable leather couch and large oak table, all lit wonderfully by electric bulbs. *This is more like the living rooms I've seen on Land's End*, he thought, *or maybe the houses on St. Mary's*. A chart was spread out on the large table.

"Mr. Cook, would you like some coffee?" asked Captain Dow. With a nod, Billy Cook was handed black coffee in a fine ceramic cup. Captain Dow briefly spoke to the third man, an engineer, who then departed.

> "…radio the tugs in Falmouth and ask them to get underway immediately to stand by my vessel."

"Mr. Cook, we are twenty-five days out of Philadelphia on the American east coast. The transit has been brutal and has taken quite a toll on my men and the ship. We are down to a few sails. I want you to confirm our location and advise me on how to proceed through these islands. I intend to depart tomorrow morning with the changing tide," said Captain Dow.

"Sir, you are here, between Nundeep and Gunners, about two miles to the west of Annet Island," said Billy as he placed his finger on the exact location. "You are in a very dangerous spot and I recommend we get underway immediately. You see that you are surrounded by rocks and ledges on all sides: here are the Western Rocks, Bishop's Rock, Crim Rock, all very dangerous."

Billy pointed to each dangerous area as he spoke. If the ship was in the middle of a clock with the ship heading to the northwest at twelve o'clock, they were surrounded by killer rocks at close range. Nundeep was off the starboard bow at one o'clock, Jeffrey Rock at four. Annet off the starboard quarter at five, Hellweathers dead astern at six, Muncoy Ledges at seven, Gunners Ledge then Great Crebawethan at the tip of the Western Rocks off the port side at eight, Bishop's Rock at nine, Flemming's Ledge at ten, Crim and North Rocks at eleven. The only consolation was that somehow the *Lawson* had been able to get itself into this predicament, passing between Nundeep and North Rock without hitting anything. And the tide was ebbing, heading west away from Annet.

"Out of the question," was Captain Dow's response to Billy Cook's suggestion. "We are anchored here for the night. Mr. Cook, we have been through a terrible transit where we fought three separate gales. I have an exhausted crew, if you even want to call them that. They have very little experience even sailing dinghies in Boston Harbor, much less getting a ship like the *Lawson* underway in a hurricane. And I have lost a lot of my sails. I maybe have six left, not nearly enough to move this ship. This ship is sail-powered. Sir, we have no screw propulsion. Have you any idea how impossible it would be to get this ship ready?" Captain Dow was shouting by now.

"Mr. Dow, I know this ship is in a tough spot," said Billy, a little startled by the captain's force of voice. "However, we must do something. I believe if we can get a few sails up in this wind and get her heading north I can take her around and slip her

> "The transit has been brutal and has taken quite a toll on my men and the ship. We are down to a few sails."

between St. Agnes and Annet at Smith Sound or between St. Agnes and St. Mary's at St. Mary's Sound."

"Mr. Cook, we will not get the *T.W. Lawson* underway. I will not let you take this vessel closer to those rocks out there. My crew is tired. The ship is clumsy and turns very wide, even if we could get enough way on to turn her around and through the channel. The anchors are holding and the tug should be here in a couple of hours. We are safer staying put. I have two of the biggest stockless anchors made—five tons each. And I have laid out 150 fathoms on the port with 90 fathoms on the starboard. These anchors have held in worse storms on the American side," boasted Captain Dow.

That's good, thought Billy, *at least the anchors are out properly*. It was common practice to lay out one anchor longer than the other. The longer anchor, normally on the port side, was the main source of hold, while the shorter anchor was backup. *Still*, he wondered, *was it enough?*

"Sir, you are not on the American side anymore. You are in the Isles of Scilly, and with no disrespect, your anchors will not hold against these seas. The seabed is covered with rocks and seaweed and the seas from the west are very strong, sir, very strong and relentless. Although the current pushing us toward the rocks is slowing, the turning tide is, unfortunately for you, sir, making for bigger waves. Your anchors will not hold, sir. You are dragging now," replied Billy Cook. With that said, the three men were uncomfortably silent for several minutes looking at the chart. It was undoubtedly the captain's call. Billy Cook's role as a pilot was to advise. He then broke the silence.

"Captain Dow, I stayed aboard this great ship of yours to perform my duties as a Trinity House pilot. Sir, my advice to you is to get underway immediately," said Billy, firmly. Captain Dow rose to his feet like a tired giant. He was a big man, about 250 pounds, and had the confidence and stubbornness of an old sea captain. About half a foot shorter and a hundred pounds lighter, Billy Cook was silent as Dow lumbered out of the room.

"I would like to check on my men. Do you have any coffee or anything hot I can send to them?" asked Billy Cook. Mr. Libby nodded and called to the steward, who soon brought a canteen of coffee and pouch full of biscuits. Cook took them and proceeded out of the captain's stateroom, followed by Mr. Libby. They were silent as they walked up the ladder and out on to the starboard deck and aft.

"Mr. Cook, we will not get the *T.W. Lawson* underway."

"Are you all right? I am sending you a can of hot coffee and some biscuits. You can't get alongside anymore. I'll send it down over the warp," yelled Billy Cook down to the crew of the *Charles Deere James*, bobbing like a cork at the stern of the ship.

The men in the lifeboat grabbed the package and struggled to eat and drink it as comfortably as possible. This was not easy with their oilskins and lifejackets on and waves crashing over the sides of the lifeboat. Billy Cook then turned to Bent Libby.

"Your ship is in a tough spot. You should slip your anchors and get underway," said Billy.

"Even with all our sails we have trouble tacking through the wind. We have to wear around if we are to turn and I don't see the ocean to do so," said Bent Libby. Billy didn't answer, preferring to look down at his mates in the *Charles Deere James*.

"We have been through three gales on the way over. My crew is beat up and tired. And I think the captain is right, our anchors will hold," Bent Libby went on.

"I pray you are right, sir, because if they don't you will certainly ride up on those rocks over there," said Billy as he pointed to Annet and Hellweathers. "And I have seen many ships and men ride up on those rocks. Very few get to shore alive." After a pause, Billy asked, "What is in your holds, sir?"

"We are carrying lubricating oil, two and a quarter million gallons, bound for London," replied Libby. Billy quickly did some easy math in his head: *That much lubricating oil is worth something. And this ship is certainly worth something if I can save her.* Billy suddenly heard a loud crashing wave hit the *Charles Deere James*. He leaned over and yelled to the crew below.

"You all right?" asked Billy.

"Something is wrong here, Billy," replied coxswain Mortimer.

"What's the matter?" asked Billy.

"William Francis is here in the bottom of the boat and is absolutely unconscious," replied Mortimer.

"What's happened?"

"Don't know. I checked aft after that last wave and there he was, absolutely gone to the wide. We got the brandy bottle and a mug and poured some out and tried to get that down his neck but he couldn't take it. We shook him and shouted at him but he is just like a dead man," replied Mortimer. "What are we going to do? We can't stay here like this. The man may die or be already dead. What about it?"

> "William Francis is here in the bottom of the boat and is absolutely unconscious."

"You cannot get alongside or you'll smash your side in. The only thing to do is take him ashore. That is the only answer," replied Billy.

"Will you come along with us? Come down the warp and ask the captain and crew to come as well, because if we leave go from you now to take this sick man ashore, it'll be impossible to get back again. It is blowing a hurricane now," shouted Mortimer.

"Hold on a minute, I'll have a word with the captain," yelled Billy as he turned and walked back to the stateroom with Libby in tow.

"Captain, sir, one of my men is sick and the lifeboat must return. I beg you to abandon this ship and let us save the crew," said Billy Cook.

"No. Out of the question. These anchors will hold. You are welcome to stay, Mr. Cook, and see how right I am. But as for abandoning this vessel the answer is no," said Dow. Billy again calculated the value of the ship and his chances and said a prayer. He then hustled to the after part of the *Lawson* and yelled down to his mates.

"You go ashore. I'm remaining here. The captain guarantees his chains and anchors. Take William Francis ashore, but after you're ashore and get him right, keep an eye on me all night for my riding lights. If we get into trouble here whatsoever, I'll fire rockets. Good night," said Billy.

The warp was untied and the *Charles Deere James* was underway toward St. Agnes. Freddie Cook looked up at the great ship and at his father along the rail. He returned a quick nod from his father. It was about ten o'clock and the tide was in the *Lawson*'s favor, for now. Those waves, though, were trouble.

Back on the *T.W. Lawson*, Billy Cook hung at the rail on the port quarter for as long as he could see the lifeboat. Pushed by the following seas, it disappeared in among the rocks of Annet and Hellweathers, Billy looked at the sparse lights on St. Agnes, his home, and the outline of the tiny island. The great ship was bucking with every wave, and he could feel the strain of the anchor chain and steel ship as it fought to stay in position. He felt the port anchor slipping. *God, I hope these anchors hold.*

The wind was howling onto Billy Cook's back, pushing him to the rail. His salt-and-pepper beard was beginning to gather ice along the chin. It was cold, in the thirties, but Billy Cook didn't really notice. He just stared into the distance, toward his

"No. Out of the question. These anchors will hold. You are welcome to stay, Mr. Cook, and see how right I am."

home, where his family was settling in for the night. He worried about how his wife Elizabeth would take the report of him remaining on the *Lawson*. Not well, he knew it already. She was going to be worried.

Billy surely thought about his children. He and Elizabeth Ann Hicks had nine altogether, three boys and six girls. His oldest was Obadiah Isaac, twenty-five years. Freddie Charles, known as Freddie Cook, his middle son and his partner on the lifeboat, was twenty years old. His joy was the youngest child, Elizabeth Augusta, born in 1900. She was just seven, and she was now, he thought, getting ready for bed. With light brown hair, Elizabeth Augusta was no doubt fighting a losing battle to stay up with her mother and siblings. This was a big night—Daddy was out on a big American ship in a storm. Billy chuckled. This little girl loved the sea, she even wanted to be a pilot, told him that during her birthday party just two months ago.

"Brought you a hot cup of coffee, Mr. Hicks, thought you might want a cup to warm you up," said Bent Libby as he joined Billy on the rail.

"Thank you, Mr. Libby," said Billy, a little surprised to see the first mate out in the cold wind with him. We can only imagine the conversation these two men had at the rail:

"Do you think the lifeboats are back in port now?" asked Libby.

"Yes I think they should be in now. If the boys on St. Mary's were able to contact the *Lyonesse*, then they should be here just before daybreak, at least by six, I would think," replied Billy.

"You think there may have been a problem?" asked Libby.

"Well, sir, the Isles of Scilly have been ignored for many years by the mainland. We are simple people here with very simple means. It wasn't until just three or four years ago that we got our life stations on St. Mary's and St. Agnes fixed up, and got two new lifeboats. The telegraph works sometimes, sometimes it doesn't. I should think on a night like this, the boys will keep trying until they get through," said Billy.

"I hope so. This ship will need a tug to get us out tomorrow, I suspect. The rocks you described are brutal. Do you get many wrecks on the isles?" asked Libby.

"Mr. Libby, we do get a lot of wrecks. There isn't a rock around these islands that doesn't have a ship or two or three to its

He felt the port anchor slipping. God, I hope these anchors hold.

credit. And there were stretches years ago that we would get a big wreck each year. Many of our beaches are covered with debris from these ships. The Isles of Scilly, sir, are a very dangerous place," said Billy.

Both men stopped talking and began to stare toward St. Agnes and Annet, noting their dark low silhouettes in the distance. It is easy to miss these islands if you aren't sure where you are. The waves were crashing onto the shores of Annet and the surrounding rocks with more frequency, sending white foam into the air, briefly lighting the darkness around them, and illuminating for a short second just how dangerous the situation was.

"Mr. Cook, do you have a family?" asked Libby.

"Yes I do. I have nine children. One of my sons was on the lifeboat with me. How about yourself?" asked Billy.

"I have five children and a wonderful wife, Annie, back in Boston. I miss them very much," replied Libby.

"The sea life is tough on children, certainly you know that, Mr. Libby. Have you been a mariner for many years?" asked Billy.

"I sailed my whole life until two years ago, when I left the sea and joined a firm in Boston called Armour. I had no intention of going to sea again until Captain Dow called for me six months ago. I sailed with Mr. Dow for many years on the *Auburndale*, a barkentine out of Maine. Made first mate under him," replied Libby.

"Why did you return to the sea life, Mr. Libby?"

"Captain Dow has been good to me. He made me first mate, something I am deeply indebted to him for. When he took command of this schooner, he wanted someone he could trust for a mate. The crew we got is mostly hodgepodge and not very good. Most came over with the spring line. They are a tough crew to handle. I said I would sail with him for one last cruise. When we return to the States, I will go back to my old job at Armour and Company."

"How many times have you crossed the Atlantic?"

"I have crossed many times on the *Auburndale* and other ships. Even rounded the horn a couple times. But this is the first time the *Lawson* has crossed the Atlantic, the first big cruise for Captain Dow and the crew. Captain Dow took over a couple of months ago," said Libby.

"And what did the ship do before that?" asked Billy.

> Both men stopped talking and began to stare toward St. Agnes and Annet, noting their dark low silhouettes in the distance.

"The *Lawson* was launched in 1902 primarily to haul coal on the American east coastal trade. We were refitted last year with seven pairs of tanks to handle bulk oil. The ship normally transported the oil between Philadelphia; Sabine, Texas; and Norfolk, Virginia; all ports that had a deep enough harbor. We draw about thirty-two feet fully loaded," said Libby.

"Thirty-two feet?" said Billy as he quickly calculated the depth around the *Lawson*. Gunners Ledge got down to ten feet real fast. The area outside of Annet, at Minmanueth and George Peters Ledge and Shag Rock, was surrounded by rocky bottoms about fifteen feet down. These spots encircled the *Lawson*. How did they get here without hitting any rocks? "My, Mr. Libby, that is quite a draft for these waters. The situation is indeed very dangerous. The wind has picked up to over thirty-five knots. I think we have to slip the anchors and get out of here before the tide floods. Once that happens, with these waves, our fate will rest on the links of your anchor chain and the hold of your anchors. If they go, we are in trouble," said Billy.

Overnight on St. Agnes

Crew on Bishop's Lighthouse relief duty. George Mortimer, coxswain of the *Charles Deere James*, is on the far right.

The *Charles Deere James* ran before the wind all the way back to the lifeboat station at Periglis Bay. With a full wind blowing and heavy following seas, it was a struggle to keep the boat on course and avoid getting swamped. As they entered the small bay, they doused both sails and lit a green flare to show the signalmen they needed assistance. It was about eleven at night and the tide was about to flood, but it was still too low for the short slipway, so they headed for the long one. The lifeboat's three-inch-thick galvanized tiller, about five feet long, was bent from the strain of the heavy wind and seas.

The signalmen met the *Charles Deere James* as it pulled up onto the slipway, attached lines and began to haul the lifeboat up out of the water. The men jumped out as they could, starting in the front of the boat and working back. Every one was waterlogged, head to toe, from their southwestern waterproof hats to their heavy leather boots. And every last one was exhausted.

"You boys look like Troy-Town. What happened out there? Where's Billy Cook?" asked James Legg, one of the signalmen.

"Jesus, what a mess. The captain wants to ride her out at anchor. Billy stayed with her. William Francis is out. We need to get Dr. Brushfield quick. William Francis had a heart attack, might be dead already," said Jack Hicks, at seventeen and a half the youngest man on the lifeboat, as he helped pull William Francis out of the boat and up the slipway. They placed him, still unconscious, in the lifeboat station for a few minutes to gather their thoughts, then proceeded to the old Lewis cottage, just up the road. A signal was sent to St. Mary's for Dr. Brushfield. The men dispersed to change into warm dry clothes, agreeing to meet at the old lighthouse right away.

"You would not believe it out there. It is brutal. And the captain of the ship wants to ride out the storm at anchor. Billy Cook stayed with them," said Jack to his mother, once he was dry and sitting in the kitchen. "Is Father back yet?" Osbert Hicks had been off the island that day, away doing Round Island relief with four other men and giving young Jack an opportunity to fill in with the lifeboat crew.

"Yes, he's back, at Israel's. They saw the ship but couldn't get out to it because of the weather, so they came back," replied Jack's mother, handing him a cup of black coffee. The two boys, Jack and Fred, drank their coffee and left for the lighthouse, asking their mother to tell Osbert Hicks to join them when he returned.

When they entered the lighthouse they immediately climbed to the top and focused in the direction of the *Lawson*, trying to pick out the riding light. After a few minutes they spotted it, in what appeared like a stable position. It was about one in the morning; the tide was almost a full flood and seas were heavy from the west. The wind continued to veer to the northwest, indicating that the center of the low-pressure area that created this gale was passing through. Soon they were joined by other members of the lifeboat crew—Obadiah Hicks, George Mortimer and Freddie Cook.

"You see the *Lawson*'s lights, Jack?" asked Obadiah Hicks.

"Yes, right there. Looks like they are steady and holding. Maybe that captain was right," replied Jack. Obadiah grabbed the binoculars and made out the riding lights of the *Lawson*.

"Well, we'll see. I just don't like anything about this situation," said Obadiah. The oil lamps were still burning, which helped keep the men warm as they sat there silently, deep in their thoughts, exhausted, scared and nervous, wondering what was

The steamer tug *Lyonesse*, out of Falmouth, was called to rescue the *T.W. Lawson* on the evening of December 13, 1907, but never made it owing to bad weather. Seen here circa 1905.

to become of the great ship and of their friend and Freddie's father, Billy Cook.

At about 1:50 a.m., Freddie Cook yelled out to the other men, "I don't see the lights. They're gone! Anybody see them?" The men stood up and stared in the direction of the *Lawson*. Nobody could see the riding lights anymore.

"She's in trouble. Let's go. Let's get the crew together and get out there," said Freddie Cook.

"Maybe her lights just blew out or broke. Happens all the time," replied Jack Hicks. George Mortimer and the others nodded. It was true: running lights, anchor lights and standing lights were notoriously unstable.

"We have to get out there. I know she is in trouble. What do you say, George, let's go," pleaded Freddie. George Mortimer, the man in charge of the lifeboat, sat silently, looking down at his feet, not answering.

"We have to get out there. I know she is in trouble."

"We stay here. The weather is too dirty. I won't risk the lives of the crew to go repair a broken light on a seven-masted American ship. Billy said he'd signal us if there was a problem. I see no signal. He is probably asleep," said George Mortimer, firmly.

"Listen, our job is to save lives, especially if it is one of our own. You know that. We are members of the Royal National Lifeboat Institute. We are charged with manning the lifeboat to save men. You know what the church glass says: 'To those who put to sea from St. Agnes to save the lives of others.' We see it together every Sunday. We can't just sit here. The light may have just gone out, but it might be worse. Maybe she's dragging anchor," said Obadiah.

"Obadiah, I am completely aware of our role as lifesavers. I am also aware that as coxswain I need to consider the safety of the crew. It is too rough. We are staying put," said George.

"It is no rougher than when we rescued the crew of the *Seine*. Remember the bark that wrecked six years ago, January, a Friday night. The coastguard saw her first. She was having difficulty sailing in that awful gale, the worst in twenty years they said. All her sails were blown away with the exception of the two foretopsails, which were in ribbons anyway. She grounded at Perran and after a few tries our rocket brigade got a line across. We pulled half the crew through the surf one at a time until the rocket apparatus broke, then we got the rest down on lines from over the side of the ship. Remember Hounsell and Higgins? They jumped right in and saved them. Didn't even

hesitate. We saved the whole crew. And that was in the worst gale ever. This storm isn't nearly as bad," said Obadiah.

"There is a big difference, Obadiah, and you know it, between a shore-to-ship rescue and taking the lifeboat out two miles in the middle of the night to see if a ship is all right. And maybe Billy slipped her anchors and got underway. That was his plan. So what do we do? Go chase a big schooner in the middle of the night in a gale out by the Western Rocks? This gale may not be the worst, but with these heavy seas and winds, it is too dangerous," said George.

"Why did Billy stay?" said Jack Hicks, breaking the silence.

"He stayed because he felt he was needed to pilot the ship. And maybe save some people. When the tug arrives, he'll help get it out past the Western Rocks. You know those boys from Falmouth don't know those rocks like Billy, not many men do," said Obadiah. "And if the tug doesn't make it, the captain will need Billy's help to clear the rocks. They have to leave on the ebb tide in the morning. Probably felt the anchors would hold and it would be easier to just stay aboard for the night," said Obadiah.

"I think the captain should have removed the crew, like we all wanted. Or slipped her anchors," said Jack Hicks.

"Captains get stubborn with their ships. Most don't want to leave until the last moment even if that means some of the crew die. You work and live on her for months and just can't bear to off and leave, no matter what trouble you get into," said Obadiah.

Obadiah reminded the others, some too young to remember, of the story of the bark *Petrellen* that went down off of Penzance twenty-two years earlier, in 1885. With the ship pushed against the shore in a gale and anchored in the roads, the captain went ashore for business, thinking his anchors would ride out the storm. When the storm got worse and the coast guard and the lifeboats were sent out, one with the captain in it to get him back to his ship, and a big crowd on the pier watching, the captain and mate refused to leave the ship, although they did let some of the crew leave. The next day when the storms let up a little, the crew returned and the captain ordered the ship underway. But as he was retrieving the anchors they parted, and the ship was driven onto the beach east of Penzance and wrecked, although everyone was rescued. "That is the way captains are—they get real funny about their ships," said Obadiah.

> "Captains get stubborn with their ships. Most don't want to leave until the last moment even if that means some of the crew die."

"That happened with the *King Cadwallon*, the steamship that went down last year in the fog over by Hard Lewis Rocks, near St. Martin's Head. That was the one that Owen Legg and his boys found in July," said Freddie Cook.

"That's right, you boys remember that?" said Obadiah. "The *Cadwallon* had her fore compartment full of water and she was certainly going down, but the captain and crew all stood by their ship. The captain only went to St. Mary's briefly to wire for a tug in Falmouth and then went right back aboard. The crew got out the ship's boats and laid off while she listed to starboard. Several of our boats arrived from St. Agnes and the other islands, Tresco, St. Mary's, and offered to salvage the light gear on the deck and also in the ship's stores but we were refused. The captain wanted everything to go down with the ship. The only things he removed were the stores subject to duty, because the customs officers were there and took them to shore. After awhile the ship was completely submerged, and the crew, I think about twenty-six, were taken to St. Mary's," said Obadiah.

"I met that captain and I don't think he liked the Isles of Scilly. The crew, I remember, started busting up the pub at St. Mary's until the constable put a bunch of them on the ferry to Penzance. They thought we were wreckers," said Freddie. "But we all know the reason we get so many wrecks is that these isles are dangerous. I still bump up against one or the other of those rocks now and again. Half of them are underwater. Shark's Fin got me a couple times. And look at Annet and St. Agnes and all the islands. Very low silhouette. Maybe they will see Star Castle on St. Mary's or Bishop's Light from a distance, but most of the time the high waves will hide the rocks until you are right up on them, especially if you have no idea where you are."

"That's what happened to Admiral Shovel," put in Obadiah. "He had no idea where he was. Maybe he knew his latitude, but not his longitude. Even called the navigators of his five ships together and they couldn't agree. The only one that knew was a sailor who grew up around here, in Cornwall, I think, and was secretly keeping an accurate dead reckoning. He told the admiral that the ships were in danger near the Western Rocks, and the admiral hung him right there for speaking up. The sailor was right, though, as the admiral found out later when his ships sunk and he started drinking salt water."

> "We all know the reason we get so many wrecks is that these isles are dangerous."

"How is William Francis?" asked Jack, bringing them back to their own predicament.

"The Doc isn't coming until the morning. Too rough tonight. He'll be here around 8:30. We checked in on William Francis and he is still asleep. Breathing pretty heavy though," said Obadiah.

"You know what bothers me about this whole night?" asked Freddie. "There are too many signs of bad luck. Think about it. George might be right that everything is all right, but look at the signs. The *Lawson* got into trouble yesterday, Friday the thirteenth. We all know Friday is bad luck. That is the day Jesus was crucified; there were thirteen at the Last Supper. You're not supposed to start anything on Friday, especially not at sea. My father says, 'Now Friday came your old wives say, of all the week's, the unluckiest day.' And you combine Friday and thirteen and you have the very unluckiest day. The Templar Knights were massacred on Friday the thirteenth. It just gives me the spooks."

"Settle down, Freddie," said Obadiah. "That is just a superstition. I have done many things on the thirteenth, sometimes even Friday the thirteenth. Lots of merchant ships get underway on Friday, even if it is the thirteenth, so the crew won't have the weekend to get into trouble, or change their minds about sailing. Happens all the time."

"And it wasn't even my father's turn to pilot!" Freddie went on, as if he hadn't heard. "Should have been Abraham James's turn. Shouldn't have interrupted what was someone else's job. And did you boys hear the ship's bell ring when we were out there? It was ringing all by itself!"

"Freddie, I think it was ringing because of the waves. Next thing you're going to say is that the ship's cat drowned and the crew of the *Lawson* whistled up the storm themselves!" said Jack with a large smile.

"Did you boys ever hear that King Arthur and his knights visited the Isles of Scilly?" said Obadiah, trying to lighten the mood. Obadiah went on to tell the story of King Arthur, and how he and his followers fled from his enemy Mordred to Lyonesse, the land that used to connect the Isles of Scilly with the mainland. But Freddie couldn't concentrate on any stories like that right now.

"The only Lyonesse I am concerned with is the one from Falmouth. She should be here soon," said Freddie.

"There are too many signs of bad luck."

Overnight on the *T.W. Lawson*

Meanwhile, as the crew of the *T.W. Lawson* waited out in the Western Rocks for the *Lyonesse* to arrive from Falmouth, the tide flooded and the current began to build toward Annet. There was a terrible strain on the two anchor chains put out to hold the *Lawson*. Each chain link was four inches in diameter and twelve inches long, weighing close to eighty pounds. With 150 fathoms out on the port bow and 90 fathoms out on the starboard, there were nearly sixty tons of rode attached to the two five-ton stockless anchors. This is where Captain Dow put his faith.

As each wave rolled in from the west, pushed along by force-eight winds, now veering more to the north, the anchor chains snapped taut and the great ship shook violently. Unable to get a strong grip on the rocky bottom, the *Lawson* dragged slowly toward the uninhabited mound of jagged granite called Annet, now about a half mile away. Captain George Dow, First Mate Bent Libby, engineer Edward Rowe and the rest of their crew, along with Trinity House pilot Billy Cook, could do nothing now but wait.

At 1:15 a.m., Billy Cook was only too sorry to see the captain proved wrong about his anchors. The port anchor snapped with a bang, followed by the parting of the starboard anchor close the hawsepipe, about thirty minutes later, and the *Lawson* was left to the mercy of the seas.

Pointing north, the ship drifted broadside in the trough of the waves coming from the west, toward Annet and her granite sentries off the starboard beam. As they got closer, Billy Cook saw the waves crash against the rocky shore of Annet and Shag Rock off the starboard quarter, about a hundred yards west of Annet. He knew this black granite mound well.

It was only a matter of time now before the *Lawson* hit—everyone on board knew it. With haste they scurried like ants out from below decks into the rigging. It was common for sailors to climb the mast rigging as a ship ran to the shore, hoping that she would run aground, not break up, and that they could stay above the seas until help came. There was a chance that one of the lifeboats would return to the *Lawson*. There was even a chance that the *Lyonesse* would still arrive from the mainland, as promised by the lifeboat from St. Mary's the day before. And without working lifeboats, what

> At 1:15 a.m., Billy Cook was only too sorry to see the captain proved wrong about his anchors.

other options did the crew of the *Lawson* have? They couldn't jump into the raging surf—most couldn't swim even in calm water. Most sailors made a point of never learning to swim, feeling that Poseidon and the other sea gods would be tempted to test their skill if they had it.

The *T.W. Lawson* finally struck bottom about fifty yards away from Shag Rock, pinioned clockwise so that the ship now pointed toward Shark's Fin off Annet Head to the northeast. With the keel held fast to the rocks under the sea, each wave pounded the ship, forcing the masts far over to the starboard side and ripping open its steel hull. Billy Cook ran to the ratlines of the spanker mast—the seventh mast, closest to the stern—and began to climb up the rigging. He felt like he was climbing a tall smoke stack. Each mast was a massive seventeen tons, held up by three tons of wire rigging. Billy Cook knew the rigging offered a short-lived sanctuary until the chain plates gave way and he was thrown into the gelid sea. He tied a strong hitch around the rigging and his waist anyway, as he had done a thousand times on the gigs he worked around the islands. Only this time was different. Billy Cook was fastening himself to his coffin.

He was followed by others: the captain, the engineer and the first mate, along with other crew members all around them, wrapped themselves in the rigging as well. From their perches they watched their ship below meld into a melee of twisted steel, lines, waves and wind—a horrifying requiem of grinding metals and pounding surf. They knew death's work wouldn't be finished until it took a run at them. Bent Libby must have thought about his wife and children back in Boston; how she had begged him not to go, how he said he owed Captain Dow, how he promised her this would be his last voyage. Now his kids and wife would be alone.

Billy Cook, too, knew he was doomed. Bound in a wretched nest of rope and wire rigging fifty feet above the deck, he could only have hoped the end would be swift—not because he was still scared, but because he was so uncomfortable. The wind was howling at force ten—over fifty miles per hour—throwing freezing rain into his face. An oily stench filled his nose. With each heave and surge of the gigantic waves, lines snapped and whipped around his body, and the ship was literally being torn to pieces beneath his feet. His oilskins and leather boots were soaked and heavy.

The *T.W. Lawson* finally struck bottom about fifty yards away from Shag Rock.

It was dark. The storm shielded the night sky, as it had for the past four days, and produced a gray haze around the boat. The only break from this dark hell came from the incandescent waves as they crashed on the rocks and against the ship, occasionally showing the outline of the dying ship and the debris around it. As the waves pulled back, the masts would have snapped back violently to the port side, whipping Billy Cook's legs around, stretching his neck and pulling tighter around his waist. Rigging started to part. Masts started collapsing into the water on the port side, starting with the forward mast and working toward the stern of the ship, toward Billy Cook and his fellow mariners.

Screams broke through the blistering wind and waves crashing on the jagged rocks that encased the ship. They came from below and to the sides of Billy Cook, as bodies were tossed into the seas and onto the rocks. He certainly knew most of them would sink from their sodden clothing and leather seaboots. Maybe they could find some floating wreckage to cling to, and struggle with each wave for a breath, and do their best to avoid the rocks that would break and cut their bodies. Did he see and wish the poor soul good luck, as one sailor, crawling out to the bowsprit (the long steel pole that extended beyond the bow of the ship) got flipped like a pancake toward Annet? He couldn't have helped thinking about the superstition that the seas claim nine lives for every one that is saved on land. They would have no trouble claiming their bounty tonight.

"Is there any hope?" Billy Cook heard, as he struggled in the rigging. He tried to loosen the line around his waist. No luck. At the same time, he tried desperately to find footing, to prop himself up on the ratlines. Again, no luck. He was dangling hopelessly with each wave.

"Is there any hope?" he heard again, as a hand reached out to grab his foot.

"What?" Billy Cook replied, as he looked below toward the noise. It was Captain Dow.

"Is there any hope? Do we have a chance?" said Dow.

"No, we have no hope. We are now in the hands of the almighty," said Billy Cook, and with that he watched the large man untangle himself from the rigging and drop to the moving deck below. He saw Rowe and Libby drop to the deck too.

Billy Cook felt nauseated. The air was now filled with a strong stench of oil and brine. The noise was unbearable. Everywhere men were crying for mercy, occasionally their voices cutting through the wind but mostly just adding to the terror around him. The steel hull was twisting, scraping the bottom and ripping open her guts to the sea. With each crashing wave, Shag Rock was sucking the ship closer.

The *T.W. Lawson* hit Shag Rock near the sixth hold on the starboard side with such force that the spanker mast must have snapped back and forth and whipped Billy Cook into the sea on the port side, sending him deep into the water, gulping oily seawater and frantically trying to untangle himself.

The rest we can only imagine: Billy's mind racing. *Think, Billy, think. Hold your breath, get the rope off your waist, calm down. Damn this water is cold. Maybe I can get loose and swim to Annet, it's only a hundred yards away. I swam it once on a dare, just get me free and I'll do it again.* Billy reaching down to his waist and realizing: *the manila rope and wiring rigging are tightening and cutting me through at the waist. I can't feel my legs.* The mast he was lashed to maybe rising out of the water once or twice, giving him a little agonizing hope while he gasped for air, only to plunge him back down and hold him firmly underwater again. Billy no longer struggling but feeling his anger building: *Why didn't the captain listen to me? I could have done it, I could have taken this beast of a ship between Annet and St. Agnes, through Smith Sound, or even through St. Mary's Sound, I could have avoided this whole disaster, dammit. If only Dow had listened. If only we had done something!*

And finally, Billy, held for good under the water this time, bursting, bursting, holding his breath as long as he could, finally opening his mouth to inhale the cold salt water. The water forcing his throat muscles to contract, shutting off access to his lungs. And Billy finally floating far below the violent surface above, not fighting and not kicking and not suffering anymore.

On the surface, the *Lawson*'s after section, near the sixth mast, had broken free and was drifting southwest, taking with it some sailors who were still stuck in the deck rigging. The masts had already split away and sank near Shag Rock. The forward section turned turtle, exposing about 250 feet of keel. Men and debris were thrown onto the rocks of Annet. The air was filled with oil.

> With each crashing wave, Shag Rock was sucking the ship closer.

Israel Hicks' house, located near the boathouse, was used as a makeshift hospital during the rescue of the *T.W. Lawson*'s crew. The house is still inhabited in 2004.

Saturday Morning on and around St. Agnes

Freddie Cook awoke to the burning odor of oil. He looked out the lighthouse toward Annet, where the *Lawson* was supposed to be, and saw nothing. He then frantically ran down the stairs and toward the boathouse. *Please, God, help my father; keep him safe.* When he arrived, Osbert Hicks, his sons Jack and Fred, George Mortimer and several others were already there, discussing the fate of the *Lawson*.

"Surely she slipped her anchors and is out there somewhere safe. We never saw any flares. She must have gotten underway," said Freddie. The other men stopped talking and looked at Freddie.

"Freddie, the air is full of oil, something bad has happened to that ship," said Obadiah.

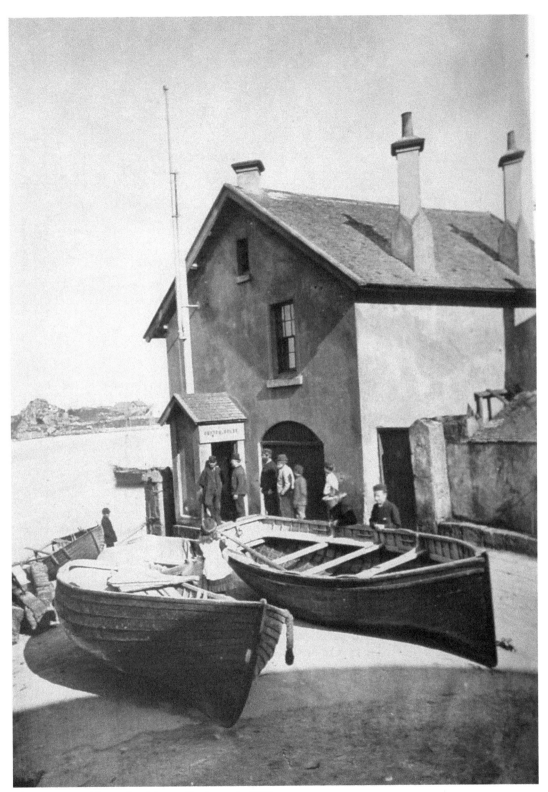

The rescue gig *Slippen*, far right, on St. Agnes in 1903.

This is the boathouse from which the lifeboat *Charles Deere James* was launched on December 13, 1907, to offer help to the battered *T.W. Lawson*. The boathouse was built in 1890 for carriage launching, which proved too difficult; in 1903 the station was improved with the addition of two stone slipways totaling 1,068 feet (the lifeboat was mounted on a trolley that ran on rails down to the water). The shorter slipway was used for high-water launching; the longer one, which was for a time the longest in England, was used for low-water launching.

The church in the background has a beautiful stained-glass window bearing the words, "In memory of those who put to sea from St Agnes to save the lives of others." The mass grave of those that died on the *Lawson* and the grave of Freddie Cook Hicks are on the church grounds, to the right.

"Then let's get out, come on, George, let's get the lifeboat out there," said Freddie.

"It is still too rough and it will take too long to get a crew together. We need at least ten. And besides, the lifeboat is no good around the rocks," said George.

"Then let's take the *Slippen*. We only need six. I'll go roust up some more men," said Freddie as he raced out the door looking for more crew. Soon he returned with help. The nine men, again mostly named Hicks, were Israel Hicks, Obadiah Hicks, Osbert Hicks and his sons Fred and Jack, Grenfell Legg, a coastguardsman, William Treneary, George Mortimer and of course Freddie Cook. The crew by unanimous vote installed Osbert Hicks as coxswain, not George Mortimer. As the crew readied the boat, Osbert Hicks turned to his seventeen-year-old son, Jack.

"You stay put," said Osbert.

"I want to go," said Jack.

"You're staying behind, son, not because you're not man enough for it; you are. But someone must stay behind and take

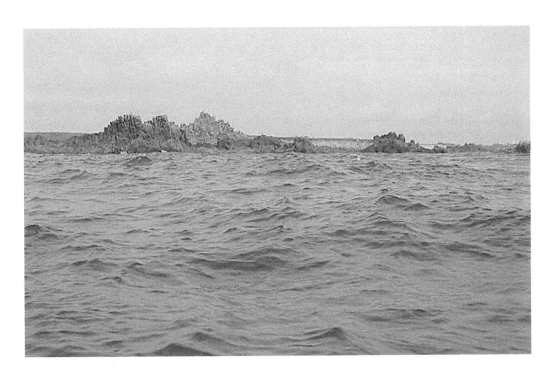

care of your mother if Fred and me don't return. I have a very bad feeling about this trip. You will need to be the man of the house," said Osbert. At that, Jack backed reluctantly away from the *Slippen*.

With the tide low, in a stiff breeze at around seven in the morning, the *Slippen* and her crew of eight were launched from the long slipway into large waves. As they approached Shag Rock, just off of Annet, the crew saw that the *Lawson* had turned turtle and was surrounded by an oil slick as far as you could see. What they saw next was shocking. Mangled bodies and limbs were washed up all along the shore of Annet Island. They landed and searched for survivors and found one, George Allen, from Battersea, near London, huddled next to a rock and screaming in pain. His side was split open and he was in shock. They returned him quickly to St. Agnes, using Israel Hicks's home near the boathouse as a makeshift hospital. It was midday now.

The *Slippen* immediately returned to the scene to look for more survivors, particularly Freddie Cook's father. After searching for a couple hours off of Annet, the *Slippen* started back toward St. Agnes at around two-thirty in the afternoon,

The islands of Annet and Shag Rock, a hundred yards to the west of Annet, were two of the low-lying hazards that lay all around the *Lawson* as it tossed at anchor. The night of the wreck, the ship hit bottom about fifty yards from Shag Rock and was pinioned there, with the waves pounding the ship and forcing the masts far over to starboard. Eventually, the ship hit Shag Rock itself, snapping the spanker mast and hurling the sailors into the sea and onto Annet Island. George Allen was found badly injured on Annet Island; he died of his wounds soon afterward.

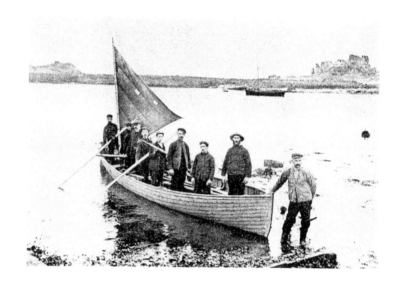

The *Slippen* several days after the wreck with many of the heroic crewmembers. Note the calm water. Freddie Cook Hicks is fourth from the stern. Osbert Hicks is on the bow, with possibly Israel Hicks in the water. More maneuverable and requiring fewer men than the *Charles Deere James*, the *Slippen* is the gig rescuers took out the morning of December 14, 1907, first searching for survivors and finding only one among the mangled bodies and body parts, then shuttling back and forth when they found the captain and the engineer stranded on Hellweather's Carn. The boat has survived to the present day, aided by several renovations and the watchful care of Maggie Tucker and the other gig shareholders. In 2002 and 2003 it was loaned to the Scituate Maritime Museum for a special exhibit on the *T.W. Lawson*.

dejected at not having found anyone else alive. Then, as they passed Hellweathers Carn, Israel Hicks spotted two men wedged in a crevice on the northern end. Somehow they had been thrown up onto those tall rocks about fifty feet off the water. Baffled at having missed them earlier, the crew was nevertheless happy to find survivors. One of the survivors was a large man, 250 pounds, holding his right arm, and wearing a torn mackinaw. The second weighed about 175 pounds, with raw bloody legs exposed below banged-up knees. Both looked tired and battered, wet and cold—but alive.

"You men alright? Looks like you have been through hell. Who are you?" said Freddie as he looked over the two men, not recognizing the captain he had seen on the *Lawson* the day before. The sun was bright and warm.

"This is Captain Dow of the *T.W. Lawson* and I am Edward Rowe, engineer," said the smaller man, shaking and still clenching a wet pack of "B.L." tobacco.

With large waves still pounding against the rocks, the *Slippen* safely kept her distance from the survivors. Maneuvering in between the two large rocks on Hellweathers Carn, the *Slippen* got about ten feet from Rowe and the crew tossed him a line. Although the junior man, Rowe was the only of the two able to help himself. After several attempts, Rowe grabbed the line and fastened it around his waist. He reluctantly jumped in the water and was pulled in to the gig, groaning and screaming in chilling pain. Both knees were smashed and bloodied. The

When Freddie Cook Hicks and the rest of the *Slippen* crew finally found Captain Dow and engineer Rowe atop Hellweather's Carn, they took the gig close to they were, threw Rowe a line and dragged him through the water into the gig and returned to St. Agnes. Rowe screamed in pain the whole way, something the rescuers never forgot. Because Dow's injuries were more severe and he was a much bigger man, they couldn't use the same approach. The rescuers had to beach the boat on the stretch of smaller rocks called Hellweather's Brow, and Freddie Cook had to scramble over those rocks, swim to where Dow was perched, secure him and then swim with Dow back to the Brow and his fellow boatmen.

Hellweather's Carn. Dow and Rowe were perched in the rock to the right. Note the wide gulf between the two large rocks.

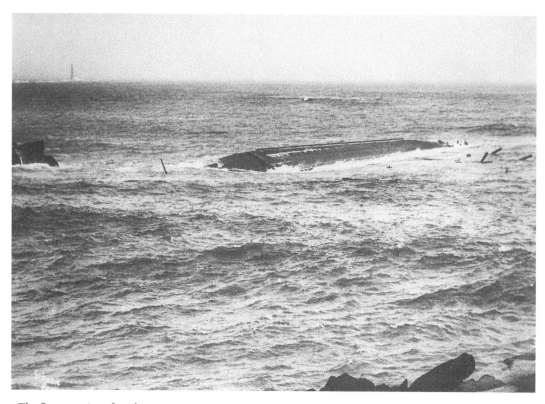

The first morning after the wreck, the ship is turned turtle. Notice Shag Rock in foreground and Bishop's Light in background left. This photo was taken from Annet.

Slippen quickly returned to St. Agnes, asking Rowe along the way about the wreck, especially the whereabouts of Billy Cook. Rowe said little. When they arrived, Israel Hicks and Fred Hicks carried him to Israel's house near the boathouse—now a makeshift hospital. Tradition has it that Isaac Legg and Albert Hicks replaced them in the *Slippen*, which immediately returned to rescue Captain Dow.

It was around four in the afternoon and the seas were still heavy when the *Slippen* reached Hellweathers again. Because Dow was in much tougher shape and unable to help rescue himself as Rowe did, the crew of the *Slippen* decided on a different plan. They beached the gig on Hellweathers Brow, a stretch of smaller rocks starting at the Carn and stretching three hundred yards to leeward. Freddie Cook jumped out of the *Slippen* fully loaded down with rope, oilskins and a life preserver and struggled across the Brow, slipping on the wet rocks and bashed by waves. Soon joined by four of his mates, he fastened one end of the rope to the rocks, plunged into the raging surf and swam the forty-yard gully to the large rock where Dow was huddled in a crevice.

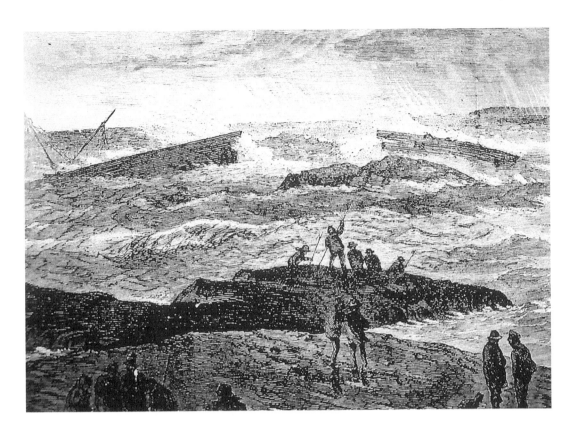

This illustration of the wreck was published in newspapers just days after the wreck

"I am Freddie Cook, son of Billy Cook, the Trinity House pilot we dropped off last night. Have you seen my father? Is he all right? Can you tell me what happened? Are there any other survivors?" asked Freddie, hoping against hope to find his father. Dow said nothing. He was in shock. He had just lost his great ship, most of his men and a local pilot. Now the son of that pilot who tried desperately to save the *Lawson* was rescuing the captain who could not do it.

After a few seconds, Freddie Cook realized the worst had happened to the crew and his father. There was nothing to do then but turn to the business of rescuing the man in front of him. Surveying his injuries, he noticed Dow's arm and shoulder were broken. Freddie took off his oilskin jacket and wrapped Dow in it.

"Are you in pain?" asked Freddie. Shivering in a wretched lump, Captain Dow did not reply. He was tormented—*Should I have taken Billy Cook's advice and gotten underway? How could we get underway, we had no sails. How come those anchors didn't hold? How does anyone survive these wicked rocks?*

Freddie Cook helped Captain Dow to his feet, fastened the line around his waist, struggled to move his big limp body to the

The crew that went out on the *Slippen* and worked all morning after the wreck and the next week, searching for survivors and finding only too few, received gold medals from the American government. The judgment calls, the long waits between action, the hard, dangerous rescue work were all part of living on these islands out beyond the tip of England, as was

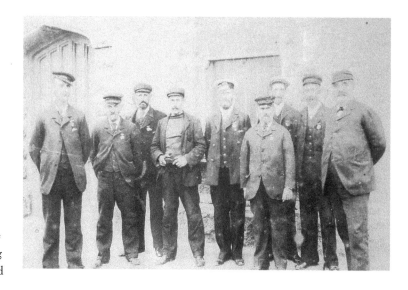

the teamwork required of these men in order to manage their rescue missions. Freddie Cook Hicks was singled out as a particular hero, and he received a gold watch from the American government and a silver medal from the RNLI, but the entire crew was also, rightly, recognized and honored.

From left to right: Israel Hicks, Obadiah Hicks, George Mortimer, Freddie Cook Hicks, Osbert Hicks (grandfather of Osbert Hicks now living on St Agnes), Grenfeill Legg, Fred Hicks (brother of Jack Hicks and uncle to Osbert Hicks of St Agnes), William Trenary and Thomas Algernan Dorian Smith.

Log book from the *Slippen*. Note the fee for "fetching dead bodies from the *T.W. Lawson*."

edge of the rock and jumped in. Freddie swam Dow across the gully, keeping his head out of the water while the crew of the *Slippen* pulled them to the other side. A little more than half the captain's size, Freddie then carried him back across hundreds of yards of slippery rocks and waves and onto the *Slippen*, where they departed for St. Agnes.

For the next several days, Freddie Cook and his mates on the *Slippen*, along with many men from many boats from the surrounding isles, combed Annet and the Western Rocks for survivors. Only Captain Dow and engineer Rowe lived; George Allen, the first survivor they'd found, died on Sunday. Sadly, they recovered many body parts along Annet; most could not be identified. The *T.W. Lawson* slowly sank to the bottom, leaking oil, eventually resting upside-down in fifty feet of water near Shag Rock. The after section rests a quarter of a mile to the southwest.

The *T.W. Lawson* slowly sank to the bottom, leaking oil, eventually resting upside-down in fifty feet of water near Shag Rock. The after section rests a quarter of a mile to the southwest.

The stained-glass window at the church on St. Agnes. The window is inscribed with the words: "In Memory of All Those from St. Agnes Who Put to Sea to Save the Lives of Others."

Making Sense
of the Story

The Aftermath

Throughout that weekend and the following week, the islanders converged on Annet and combed the area for salvageable cargo, trying to stay one step ahead of the customs agents also on the scene. Chairs, tables, rope, belay pins, sea chests, clothing and sails all washed ashore. One man found a painting of the *Lawson* on sail canvas, apparently painted by one of the crewmembers months before; he wrapped it in newspaper and stuck it into his jacket just ahead of the customs agents. He then stored it in his attic for fifty years, eventually donating it to the Isles of Scilly maritime museum, where it is on display next to a multitude of other items that washed ashore.

Unfortunately for the people on the isles, the two and a quarter million gallons of oil that were the ship's cargo were of no use, as they washed up on the shores. Although this was the world's first significant oil spill, the oil, fortunately, was light and evaporated quickly, with no lasting damage to the beautiful and unique flora and fauna on the isles. The stench stayed on the isles for weeks, but by the summer of 1908, no sign of oil was seen anywhere on the shores of the Isles of Scilly. For perspective, the spill from the *Exxon Valdez* in 1989 was five times bigger and did more long-term damage because the oil was heavier.

The *Lawson*'s crew, mostly unidentified body parts collected over several weeks, is buried in an unmarked mass grave

The *Lawson*'s crew, mostly unidentified body parts collected over several weeks, is buried in an unmarked mass grave behind the church on St. Agnes.

The crew of the *Lawson* were buried in an unmarked mass grave behind the church on St. Agnes, twenty feet away from the grave of Freddie Cook Hicks.

behind the church on St. Agnes. Pilot Billy Cook was never officially found, though rumors persist that his tortured body was also placed in the mass grave. The crew of the *Slippen* received engraved gold medals from the American government for their heroism. Jack Hicks, forced to stay home that day, inherited his father's medal years later, though he always resented not having been able to be a part of the rescue and receive a hero's medal of his own. Freddie Cook received an engraved gold watch from Theodore Roosevelt, president of the United States, and a silver medal from the RNLI. Tradition has it that he also received a gold watch from the Crowley brothers, though that remains unconfirmed. For the rest of his life, Freddie Cook spoke very little about the wreck. He is buried in a newly marked grave behind the church on St. Agnes, next to the unmarked mass grave of the *Lawson*'s crew.

On the following Monday, the *London Times* wrote about the *T.W. Lawson*, just one among many wrecks that resulted from a devastating low-pressure system that weekend. The headline was "The Severe Gale—Many Lives Lost:"

The rapid fall of the barometer noticed over England on Friday resulted in the development of a huge storm system that extended during the ensuing night over practically the whole of Western Europe…A wreck, attended with the loss of 17 lives, occurred on Saturday morning off the Isles of Scilly. It was reported on Friday night that a large sailing ship was in difficulties in Broad Sound, and the lifeboats at St. Agnes and St. Mary's went to her assistance. It was found that the vessel was the American schooner Thomas W. Lawson *5,000 tons, bound from Philadelphia for London with case oil [sic; it was actually bulk oil]. She was anchored in a dangerous position…The schooner's lights were seen until 1:50 a.m. on Saturday when they disappeared. It was thought that possibly they ship had slipped her cables and cleared the islands, but at daylight it was found that she had capsized and become a total wreck.*

Newspapers in Boston also reported on the wreck on Monday, a seemingly quick response from the other side of the Atlantic.

An inquiry comprised of seven jurors from St. Mary's quickly convened on Monday and recommended strengthening the communications between the two lifeboats, the *Henry Dundas* and the *Charles Deere James*. It turned out that although two tugs and the steamer *Lyonesse* had received the telegraph for help and quickly got underway, all were forced to return to Falmouth because of the storm.

The panel also concluded that Freddie Cook and the crew of the *Slippen* acted with bravery. And after getting a close-up view of Hellweathers Carn and Brow and watching waves on a calm day crash violently on the rocks, I can say there is no doubt in my mind that Freddie Cook was a true hero. One can just imagine the huge waves, building over miles of open Atlantic crashing on the Western Rocks. This would have created a very dangerous and frightening situation. Add to that the panic Freddie Cook must have felt as he searched for his father among the rocks and debris and you have real courage. It took determination, courage and strength to walk over slippery Hellweathers Brow, carrying rope and gear, weighted down by waterlogged leather boots and oilskins, repeatedly getting bowled over by waves. He then swam across a gully at Hellweathers Carn, grabbed a man he didn't know who was almost twice his own weight, swam with him back across the gully, then carried him over the same treacherous rocks to the *Slippen*.

The panel concluded that Freddie Cook and the crew of the *Slippen* acted with bravery.

Here's how it was described in the *Western Weekly News*, Plymouth, England, Saturday, December 21, 1907 (using Billy and Freddie Cook's original family name of Hicks):

Captain Dow undoubtedly owes his life to Fred Cook Hicks, a son of pilot Hicks who has not been found. They could not affect a landing, and Hicks thereupon took the rope and swam and scrambled through nearly fifty yards of sea and rock. His difficulties were not then over, as he found the captain helpless with wounds he had received through being tossed about, and with a broken wrist. Hicks securely fastened him with a rope, and managed to get him to the gig.

After hearing the testimony about Freddie Cook's rescue, the coroner could only say, "It was a very brave rescue." Indeed it was. Freddie Cook deserved his watch and medal, as did the crew of the *Slippen*. They were true heroes of the day. Freddie Cook continued to serve the RNLI until the boathouse on St. Agnes closed in 1920.

"Captain Dow undoubtedly owes his life to Fred Cook Hicks, a son of pilot Hicks who has not been found."

When Thomas Lawson the man went to bed at Dreamwold on the night of Friday the thirteenth he commented to his son Douglas that the great boat had survived another unlucky day. On Saturday the fourteenth, Thomas Lawson was informed of the wreck. He surmised that the *Lawson* must have turned turtle because of improper loading of the bulk oil in to tanks not properly baffled. After all, we were still learning how to transport oil in bulk. Years of prosperity and controversy would follow for Thomas Lawson, though he never regained the wealth he had at the turn of the century. By the early 1920s, several of Thomas Lawson's children and grandchildren had moved to Oregon, where he was spending most of his time. Leaving his business to attacks from his enemies, he soon lost his fortune. His Dreamwold estate in Scituate, Massachusetts, was auctioned for taxes in 1922 and Lawson died relatively poor in 1925.

Captain Dow and engineer Rowe returned to the States, after recovering enough to travel. Prior to departing Rowe presented his caretaker with a gold ring, believed originally destined for another woman. Shortly after returning, both separately and quietly made reports to the Crowley brothers. Edward Rowe even used the back stairs to the office to avoid any publicity. The Coastwise Shipping Company recovered from the loss of the *Lawson*, estimated at $150,000 for the ship and $75,000 for the cargo. The ship was uninsured

but the cargo was, and claims were made against it. The company refocused on steamships and had many years of profitability. Captain Dow returned to the sea, but for years neither he nor engineer Rowe would speak about the tragedy. Finally, almost fifty years later, Edward Rowe broke his silence.

Engineer Rowe's Report

Here's how Rowe remembered it to Captain Caughlin in 1954, as published in the *Herald and Ledger*:

> *Captain George Dow, the English pilot, W. Cook Hicks, the mate, and the cook climbed halfway up, high in the spanker rigging, scattered above me. Five of us were in the spanker rigging. Captain Dow had no life belt with him.*
>
> *Minutes after stranding on the reef, all seven masts went by the board. The starboard rigging let go. A heavy sea smacked the ship; she swung her head round with it heading straight for and up a cliff. With the masts gone, the big sticks toppling to port carrying the men with them, all was over now, including the hopes of the men borne to a watery grave with the steel sticks of the* Thomas W. Lawson. *It was every man for himself.*
>
> *When she swung head for the cliff, the seas were lifting very high and dropping low, in one, two, three order. Seaman Allen took a long chance to hop ashore. Thinking the jib boom might touch the cliff, he scampered out along the bowsprit towards the tip end. Alas, one of those high one, two, three combers swept him from the boom, washing and tossing him seventy to eighty feet over the island. He was the first crewmember to land ashore on Annet Island. It was after I got ashore on Annet Island that we got wind of what became of him. The natives on the island told me they found him with his left side ripped open, and that he lived for two hours. He was buried on the island with other crewmembers who were later washed ashore.*
>
> *As to myself, Captain, I cut a signal halyard, tied it around my body, climbed three ratlines above the sheer pole. Apprehension or something brought me back to the sheer pole. The other men were above me, scattered in the rigging. There I stood with unlaced shoes before the masts went over the side. When the rigging let go, I found myself standing on deck with the line around my waist. At this moment I grabbed a second line which happened to be near. When the ship lurched and*

"All was over now, including the hopes of the men borne to a watery grave with the steel sticks of the *Thomas W. Lawson*. It was every man for himself."

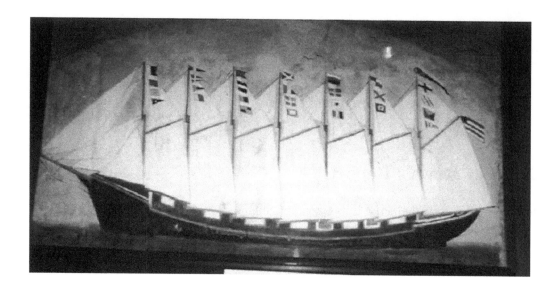

Painting of the *T.W. Lawson*, supposedly done by one of the crew on sail canvas from one of the *Lawson's* sails. It washed ashore after the wreck and is on display in the Maritime Museum on St. Mary's. The colors are arranged alphabetically, as the signalmen would do to dry them.

rolled heavily, both of the ropes jammed in the coastal doors of the pilot house after. She was beginning to break in two now between the no. 6 and no. 7 hatches. All hands were in the water.

Temporarily, I became tangled in the snarled mass of no. 7 rigging floating beside the wreck. Somehow or other, in the turmoil I managed to get clear of the rigging. Intervention, God's divine guidance, arrived temporarily, at least. Up pops a lengthy twelve by twelve alongside me. In the end of it was a good-sized iron spike sticking up. Letting go a hand of "B.L." tobacco I salvaged for future chewing if I did get ashore, I grabbed the spike…

For some three to four hours we floated about aimlessly towards the lee shore of Annet Island. Unexpectedly my feet touched bottom. I felt I was near the shore somewhere, to find myself standing on a shoal spot nearby a ledge, or part of it. I let go of the spike in the timber I had held onto so long that bleak black morning. I still have the scar in my palm from holding the spike. It bruised deeply. I grabbed the rock and hauled myself. With a little rest, I rubbed the oil from my eyes. There I stood alone, with the reef and the sea, wondering what became of the others out there in the cold, black oily waters…

It was exactly daylight when I beheld Captain Dow attired in a priestly mackinaw and life belt trudging wearily in to the dry spot with two broken ribs and a broken right arm. He was a heavy man, weighing 250 pounds, and after a fashion

I managed to haul him up into the safe spot I had dragged myself to earlier. We were both safe now to await rescue, but cold and shivering.

What Happened?

Since 2000, I have been down to the wreck many times, talked to the locals for hours and researched the tragic story of the *Lawson*. I have talked to relatives of the key players on both sides of the Atlantic. I hope the story, as I have told it here, has helped provide a more complete picture of the great ship and what happened on the Western Rocks in 1907. Although I have pieced together a lot of research, there are some questions I still puzzle over, that can't, I guess, ever be completely resolved.

Pilot Billy Cook's Decision

Why did he finally board and stay on the *T.W. Lawson*? I think Billy Cook probably sincerely felt that he could save the ship and crew, arguing vigorously that their best hope was to get the ship underway. He had been involved in many rescues and complex piloting around the rocks; he must have been pretty sure he could successfully maneuver the *Lawson* out of its tricky position. Of course, he wasn't fully aware of the *Lawson*'s awkwardness and poor sailing record; that even with all its sails on all seven masts, the *Lawson* was a clumsy schooner and often had to wear around. So the pilot's confidence might have been misplaced. But Billy Cook knew that if he saved this new, expensive American ship, he would be well compensated by the owners; he might even get to claim the ship as his own, and he would certainly gain fame throughout the isles. He must have believed that for the rewards he might hope for, the risk was not that great.

> Billy Cook probably sincerely felt that he could save the ship and crew, arguing vigorously that their best hope was to get the ship underway.

Captain Dow's Decision

It's easy to second-guess the captain's decision, but command at sea involves taking in all the information you can gather and making the hard call. Captain Dow knew that if he slipped the *Lawson*'s anchors, with only six usable sails and no safe water in which to turn and build up speed, the *Lawson* was certainly doomed. But he probably had in the back of his mind as well

the reputation of the Isles of Scilly as a wreckers' island. He hadn't yet experienced the truth: that it was the rocks themselves that were the wreckers. Given what Captain Dow knew, he was not going to abandon his vessel or turn over control to pilot Billy Cook. He would put his trust in the anchors. And although his decision certainly looks like a mistake to us now, to be absolutely fair we have to admit we can never really know. Given a little less wind, or waves or tide, maybe Captain Dow would have woken up on the morning of the fourteenth, found the tug waiting, and uneventfully gotten underway for London.

Coxswain George Mortimer's Decision

> It's easy to second-guess the captain's decision, but command at sea involves taking in all the information you can gather and making the hard call.

After the lifeboat *Charles Deere James* went back to St. Agnes to drop off sick William Francis Hicks, why didn't it return to the *Lawson*? The men I have talked to on St. Agnes were clear about this: the lifeboat should have returned that night, no matter how dangerous, and removed pilot Billy Cook, at the very least; they should probably have taken off most or all of the crew, as well, if they had agreed to go. George Mortimer, the coxswain, had the final say in this decision, and of course his primary responsibility was for the safety of his lifeboat. He clearly felt the weather was too dangerous, and of course he had some justification in this. But his steadfast refusal to go back out that night, even in the face of pleading by Freddie Cook and other crewmembers, is a source of controversy for many on the Isles of Scilly, especially relatives, who feel it was the duty of the lifeboat to attempt to save the crew, no matter how dangerous.

How Did the Lawson *Actually Wreck?*

For this I had to dive down and see the *Lawson*'s grave myself. The wreck rests in about fifty feet of water, about twenty yards off Shag Rock. It hit the submerged rocks leading to Shag Rock, turned turtle and sank. The keel and ribs are clear among the seaweed, pointing northeast toward Annet and the masts are pointing seaward, as Edward Rowe reported. Although pointing toward Annet, the bowsprit is still about a hundred yards off the shore, suggesting it would have been very difficult for George Allen to be thrown from it on to the shore (in spite of what Edward Rowe has said). It is more likely that he was thrown into the sea, splitting his side on some rocks as he washed ashore.

The after section is located about four hundred yards to the southwest of Shag Rock, proving it did split and drift away as was reported. The only part of the stern section you can see is the overhang above the rudder. This seems to suggest that it split there, instead of between the sixth and seventh hatches. However, it is difficult to say for sure since the keel and other parts of the steel hull are mangled, twisted and buried among the sand and rocks, making it very difficult to take measurements needed to know exactly where she split. For example, we measured 148 feet of keel in the forward section off of Shag Rock, but know from pictures taken on the Saturday morning after wrecking that more keel lies in the area. We'll never be able to know for sure exactly what happened, and why.

The after section is located about four hundred yards to the southwest of Shag Rock, proving it did split and drift away as was reported.

How Did I Come Into This?

I grew up in Scituate, where Thomas Lawson had his Dreamwold estate, and I came back here to live as an adult just a couple of years ago. Situated along the coast, south of Boston, I think this town is beautiful. Scituate is known for its four gently sloping cliffs, glacial deposits of till called drumlins carved out by the waves. In between each is a wonderful, rocky beach. For years, people harvested Irish moss from these rocks.

The things I remember about childhood in Scituate are the ocean, the cliffs, going to the beach and sailing. I was always sailing with my mother and father and brothers and sisters, all around Massachusetts Bay and the islands. We always had a boat, and I really grew up along the water.

You could smell the ocean all the time. You could smell the marshes at low tide, the seaweed and the Irish moss. The mossing industry died out in the mid-1990s, when Irish moss became available more cheaply from Canada and South America, but historically, it was Scituate's town industry. Every morning you could look out to the ocean and see ten to twenty dories manned with strapping young men, using iron rakes on long poles to pull hunks of seaweed off the rocks. By the time I was growing up in Scituate, they used big commercial dryers to dry the moss; the traditional way, though, after they had collected the moss from the rocks, was to dry it on the beach for a couple of days. The beach would be draped with drying moss, turning colors. This is how the Irish moss used for shampoos, for instance, is produced. Back then, Scituate

Top and bottom: Steel masts
of the *Lawson* up close.

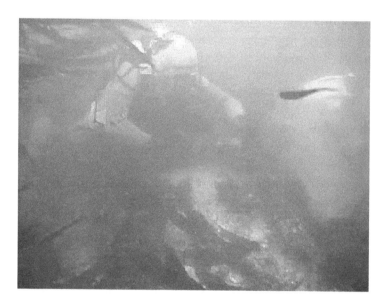

was the only place in the world outside of Ireland where Irish
moss was harvested.

Now fishing and lobstering are the only industries in town, and
of course there are a lot of commuters to Boston. In Thomas
Lawson's day, the population was maybe three or four thousand.
During my childhood in the 1960s and 1970s, there were about
eight thousand year-round residents, and that number doubled in
the summer. Nowadays there are eighteen thousand year-round

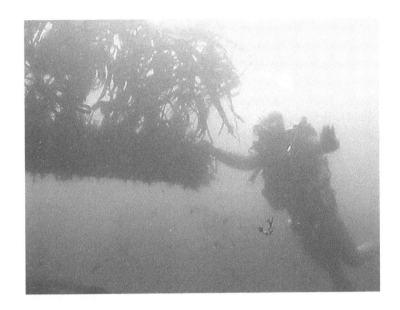

Deep below the ocean's surface, 148 feet of the *Lawson*'s keel remains intact.

T.W. Lawson plate underwater, 2001. Note rivet holes.

residents and only a couple of thousand more come in the summer (more of the people who used to come for the summer now just stay all year). In fact, even though there is no train to Boston as I write this, the track bed for the direct "Greenbush" line from Scituate to Boston that Lawson used is still there, and new tracks are going to be built and train service restored.

Thomas Lawson's old Dreamwold estate was long since broken up, but a lot of the individual buildings are still

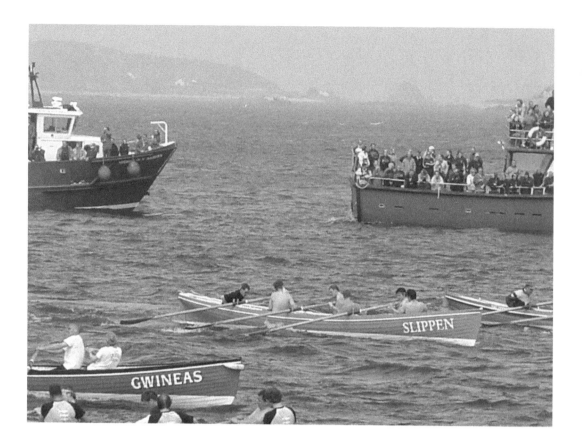

The *Slippen*, restored in 2001, racing in world-famous Gig Championships on the Isles of Scilly in 2003.

around. The beautiful fifteenth-century German tower replica he had built around the ugly water tower is still there, and when you're out sailing around Scituate the tower is always a landmark. When I was growing up the tower was open to the public once a year and we would go up into it. It has become the most photographed tower in the States. The tower is also just a hundred yards from the junior high school, so we kids couldn't miss it. The racetrack was gone, and the stables were broken up to make other buildings, but the main house, the mansion, still exists, along with maybe eight to ten other buildings. When I was a kid, there were still people in town whose parents had worked for Thomas Lawson, and there were plenty of stories in town about him, about how he was always fighting the town for things he wanted to do or have done and how he was making and losing his millions.

So this is my town, the town I grew up in. And as I said, the story of Thomas Lawson—the man, his schooner, his tower, his mansion, his wealth—is all around when you grow up in Scituate.

T.W. Lawson dive crew. From left to right: Alec Collyer, George Gradon, Mervyn Waldron, Mark Groves and Julia Peet.

The story of his seven-masted schooner has become more and more interesting to me in the last few years.

In April of 2000 I decided to fly to the Isles of Scilly and investigate the wreck of the T.W. Lawson, which I'd gotten curious about over the years. I was living in Greece at the time, working for a German company. I had time over a long weekend, so I figured I'd go satisfy my curiosity. Even though Mark Groves, the master diver on St. Mary's I got in touch with, told me he was too busy with the Pilot Gig Championships that weekend, and the weather was very bad, I still went. I flew to London, took a train to Penzance and helicopter to the isles, walked to Mark's shop and knocked on the door. The weather calmed down a little the next day, and Mark took me down to dive on the wreck of the ship.

When I finally got to dive on the wreck of the T.W. Lawson, the whole story of the schooner, the wreck and the rescue became much more real to me. First of all, the weather actually was reasonably calm when we went out, but even under those circumstances, I could see how treacherous the rocks and the

The *Slippen* was renovated by Peter Martin in 2002. Here Grant Tucker surveys the progress.

Osbert Hicks showing my daughter Chloe one of the gold medals awarded for heroism during the rescue efforts.

waves could be. I realized what heroes the rescue boat crew and especially Freddie Cook truly were, going out to search for survivors in those conditions.

Even though I've been diving since I was a kid, I got so excited diving on the *Lawson* that my air ran out too soon. It didn't help that I swam around holding the first piece of *Lawson* booty I could find—a heavy piece of the hull plate covered with barnacles! The current was throwing us back and forth, and we had to be careful not to be thrown up against the jagged metal of the wreck.

We weren't the first people ever to go down there: in the spring of 1908 insurance companies sent professional divers down to see whether the anchors had really broken, but they couldn't definitively determine it. And in 1969, the *Lawson* wreck was rediscovered by a diver on the Isles of Scilly, so now it is on the maps of wrecks around the islands and visitors go to it occasionally. Sport divers tend to be more interested in much older, historical wooden ships like Shovel's fleet wrecked in 1707, so I don't think the *Lawson* attracts a lot of divers.

On that day in April, after Mark Groves had taken me diving about a quarter mile away from the island of St. Agnes, we agreed

Left to right: Alec Collyer. George Gradon, Julie Peet and Thomas Hall dive near the wreckage.

he would drop me off so I could go call on Osbert Hicks. Osbert Hicks is the son of Jack Hicks, who was the youngest member of the crew on the *Charles Deere James* the night the *Lawson* wrecked. Jack Hicks was also the one who was not allowed to go onboard the rescue boat *Slippen* the next morning, because his father and older brother were already onboard. His father wanted someone to stay behind, in case anything happened to them all, to help take care of his mother and the rest of the family. As it happened, of course, no one on the *Slippen* died—in fact they all got medals for heroism—and Jack was full of resentment his whole life at having been shut out of that glorious rescue.

After I'd changed out of my wetsuit, Mark dropped me off on St. Agnes and pointed me toward the house, and I went up. I literally just walked up there, past a couple of cows on the lawn, knocked on the front door, and Osbert Hicks, the nicest guy in the world, took me in and talked with me for about two hours.

Osbert Hicks is now in his seventies and lives in the house on St. Agnes he's lived in his whole life, a cottage that's been in the family for two centuries. From his cottage, you can see the spot where the *Lawson* anchored almost a hundred years ago. Only

Joe Hicks, son of Freddie
Cook Hicks, in 2000.

sixty people live on the whole island now. The story of the *Lawson* wreck was one that had a great impact on his father's life, and he had a lot of stories to tell and information he filled in for me, sitting up there in his old family house that overlooks the entire Western Rocks.

Over the next few days, and again on my next visit, he also took me all around the islands in his boat, showed me where the *Lawson* wrecked and where the survivors were rescued, and showed me one of the gold medals awarded to the boat crew. The second time I went to the isles, I took my ten-year-old daughter Chloe with me. She went out in the diving boat and stayed above, handing things over and helping to man the boat.

On each trip I made to the Isles of Scilly, I met a lot of people who had things to tell me, things to show me. On the island of St. Mary's, the main pub is called the Mermaid, and that's where everybody goes. In the pub, and all over the islands, people would come up to me (many of them from the sprawling Hicks clan) to introduce themselves and talk. I got to meet John Hicks, Israel Hicks's son, on St. Mary's and then again when he visited

In front of Osbert Hicks's cottage St. Agnes, from left to right, are grandson Aiden, wife Pam, Osbert and Mervyn Waldron.

Boston, and Joe Hicks, Freddie Cook's son, in a home on St. Mary's. One man I met, Gilbert Pender, said, "Come back with me and see what I have in my backyard." He had a backyard full of salvaged things, and he pulled out a porthole, and said, "Here, this is from the *Lawson*!" I couldn't imagine how, with all the stuff he had piled up there, he could know that this particular porthole was from the *Lawson*, but he told me he remembered exactly who had given it to him, somebody who had been diving on the *Lawson*. And sure enough, the dimensions exactly matched the specifications on the plans for the *Lawson* portholes.

Meanwhile, back in Scituate, the Scituate Maritime and Mossing Museum, started in 1997 by Dave Ball, was expanding its focus. Originally focused on the Irish mossing industry, it was becoming more of a maritime museum as well, with exhibits on wrecks around Scituate and other places. The museum is in a two-hundred-year-old house that was first owned by an old captain called Benjamin James, and was later a smallpox hospital, with its own smallpox burial grounds nearby. In 2002, Dave Ball, president of the historical society; John Galluzzo, the

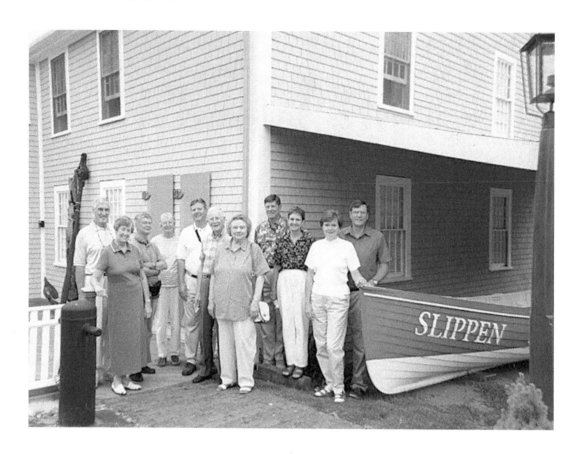

In the summer of 2002, Mike Gurr form the Maritime Museum on St Mary's and his wife came to the *Lawson* exhibit in Scituate and were joined by the Calderone and Quinn families, descendants of Captain Dow. Here they gather next to the *Slippen* exhibit.

executive director; and Pam Martell, museum exhibit designer, set up an exhibit devoted to the wreck of the *T.W. Lawson*.

The centerpiece of the exhibit was the *Slippen*, the rescue gig that went out the morning after the *Lawson* wreck, on December 14, 1907. Built in 1870, the *Slippen* is twenty-eight feet long and six feet on the beam. We got permission from Maggie Tucker and the owners of the *Slippen* in the Isles of Scilly to bring the original gig here to Scituate, but it was quite an adventure making it happen. Before it left, it was completely renovated, helped by a small contribution from the Scituate Historical Society. Since it is a historic gig, a cradle had to be built before departing to protect the boat inside the forty-foot container it would be shipped in. The gig was transported on a small ferry, the *Scillonian*, to Penzance. From there it was trucked to Portsmouth, shipped to Boston and then trucked to Scituate. Local papers on both sides of the Atlantic covered it.

The museum's exhibit included artifacts like portholes from the *Lawson*, historical documents like the *London Times* report, and underwater footage from the dives expertly put together

Osbert Hicks in front of the unmarked grave of Freddie Cook Hicks, behind the church, in 2002. It has since been marked.

by Alec Collyer, the BBC's underwater photographer. In the summer of 2002, Mike Gurr from the Maritime Museum on St. Mary's visited with his wife, and the Calderone and Quinn families—relatives of Captain Dow—came for the day to also see the exhibit and especially the gig *Slippen*, so instrumental in saving Captain Dow.

Before the *Slippen* returned to the Isles of Scilly in 2003, it was raced in some charity events by Team Saquish, a gig rowing team from Plymouth, Massachusetts, who specialize in racing this kind of Cornish gig. During one race in Hingham Bay, the *Slippen* passed by the old Fore River shipyard that built and launched the *T.W. Lawson*, a fitting salute to the great ship and crew it helped rescue a century earlier.

Following pages: Life ring from the *T.W. Lawson*, now held in a museum on the Isle of Tresco, Isles of Scilly.

BIBLIOGRAPHY

Hundreds of articles have been written over the years about the *T.W. Lawson* and not all have their facts straight. I found the following to be the most accurate and informative and drew heavily on them for this book.

Dyal, Donald. "Death of a Schooner." *The Log of Mystic Seaport* 1983.

Hornsby, Thomas. "The Last Voyage of the *Thomas W. Lawson*." *Nautical Research Journal* 5 (April 1953).

Larn, Richard. *Cornish Shipwrecks*. Vol. 3, *The Isles of Scilly*. Newton Abbott, England: David & Charles, 1971.

Miles, Carol, and John Galluzzo. *Beauty, Strength, Speed: Celebrating 100 Years of Thomas W. Lawson's Dreamwold*. Virginia Beach, VA: The Donning Company, 2002.

Ronnberg, Erik Jr. "Stranger in Truth than in Fiction: The American Seven-Masted Schooners." *Nautical Research Journal* 38 (March 1993).

All of my research, including the articles and book above, other articles, pictures and BBC documentaries, is available in the Scituate Historical Society research library. The museums and societies mentioned in the book also have extensive material on the *T.W. Lawson* available to researchers.

About the Author

Author on Shag Rock, Bishop's Light in back left, wreck just behind Shag.

Thomas Hall grew up in Scituate, Massachusetts, home of Thomas W. Lawson. He has researched the seven-masted schooner *T.W. Lawson* thoroughly, including numerous dives at the wreck on the Isles of Scilly. He has lectured extensively on this topic around New England and the United Kingdom. He appeared in the BBC documentary *T.W. Lawson* in 2000.